Unlocking the Fretboard
&
The Art of Fingering

How to accurately interpret and transfer information from standard notation to the guitar while facilitating left hand motion

Harry George Pellegrin

Copyright 2011, Harry G. Pellegrin. All rights reserved. No part of this book may be reproduced or transmitted in any form or by any means, electronic or mechanical, including photocopying, recording or by any information storage and retrieval system without express written permission from the publisher.

PAB Entertainment Group
P.O. Box 2369
Scotia, New York 12302
www.pellegrinlowend.com

Printed in the United States of America

Unlocking the Fingerboard
&
The Art of Fingering

Cover designed by £ Pound Sterling Graphics

Library of Congress Cataloging-in-Publication data is available upon request.

ISBN 978-1-304-94789-5

Pellegrin, Harry G., **Unlocking the Fingerboard & The Art of Fingering**

Copyright 2011

Introduction

I believe the guitar suffers humiliation due to two commonly held—and erroneous—precepts. The first is that the guitar is somehow a lesser instrument to the orchestral instruments as well as the piano and other keyboard instruments. The second humbling misconception, one that has more than an iota of truth in it, is that guitarists, as a rule, are somewhat less than serious musicians. These two frustrating beliefs are tied together and directly caused by an unlikely foundation—that the guitar suffers from its own popularity! This societal condition or set of circumstances seems to occur with an almost palpable regularity throughout its history. The guitar had been relegated to the lower class of the population and, by popular misconception, to an inferior repertoire prior to the days of Mauro Giuliani (d. 1829), Fernando Sor (d. 1839), Ferdinando Carulli (d. 1841), Dionisio Aguado (d. 1849), Matteo Carcassi (d. 1853), and it was these estimable gentlemen who carefully and lovingly brought the guitar back to its rightful place in the salons and recital venues of Europe. A mere two or three decades after the last of their passings, the guitar had once again been relegated to the proletarian world of the public house and firmly placed in the hands of the dilettante.

Francisco Tárrega (1852–1909) and Miguel Llobet (1878–1938) began to mend the instrument's reputation through composition and transcription and this nascent renaissance flowered through the diligent efforts of Andrés Segovia (1893-1987) and by his unrelenting nurturing, the guitar was *almost* restored to a place of honor. Even before his death, the seeds of the next descent to ignominy had been planted. Upon each wave of popularity the guitar enjoys, there rides its bane. While Segovia was ceaselessly concertizing and engaged in mitigating for guitar programs in colleges, expanding its repertoire through transcription and patronage as well as downright threat, the cowboy singers, the blues musicians, and ultimately the genre of rock and roll where placing the guitar into the hands of dilettantes once again. It would seem that by the 1960's anyone who could find, finger and execute three or four simple open position chords on the instrument considered themselves guitarists. Worse still, they tacitly led others within earshot to consider them guitarists as well! It did not matter that the cowboy singers were merely singers who accompanied themselves with the instrument and never would have declared themselves *guitarists* and the blues musicians, while possibly not as technically proficient as the classical recitalists of the world, still produced the basic hallmark of true musical art—they conveyed deep emotion through their playing. Still, to the general public, the guitar was that instrument upon which that kid next door produced great quantities of noise. Taken a step further, the 'guitarist' was not really a musician—the few chords he or she played only took a week or two to learn and, accordingly, so ill equipped, this "guitarist" could not read music or rationally discuss the art with other more trained (and serious) musicians. The classical guitar is no easier than any other instrument to either learn or play. I have students who are quite proficient on other instruments who declare the classical guitar to present greater challenges than their primary instrument! Indeed, some intrinsic facets of its nature lead the dilettante to eschew a true musical education: "It's just too hard to read 'real' music on the guitar!"

In 2006 my ***Classical Guitar Method*** was first published. I had deemed it then *the single volume the student needs to successfully learn the classical guitar.* Of course, as soon as the ink was dry, so to speak, it was already in revision! The third edition of ***Classical Guitar Method*** includes a synopsis of many of the articles in this book, and it still may be considered the single volume the student needs to successfully learn the classical guitar. It is not necessary to purchase this book if the student has the third edition is his or her possession. As its first purpose, this volume is aimed towards the needs of the player who wishes to improve his or her sight-reading ability. The fretboard does indeed have an easily recognizable arrangement of half steps and intervals; one that once understood becomes almost as graphically representative as the piano keyboard. This volume focuses on this underlying principle and develops it into a system encompassing both the *horizontal* as well as *vertical* methods of learning the fingerboard and in what way to combine the two disciplines into a seamlessly coherent system. Past this, the diligent guitar student will find insight into why transcribers, editors and performers have varying opinions on fingering options in identical pieces. Please note I state *opinions* as fingerings are indeed merely opinions; they are not engraved in stone. Some editors finger music so for ease of performance. Indeed, in some cases there may be only one way to finger a passage due to open strings, pitch duration, a plethora of reasons. Still, what may 'work' for one performer with his or her unique musculature and physiology may simply not work for another. Factor in the timbral changes performing a passage on a different string or strings and how the performer wishes to

interpret the composer's intent and one can readily see that any number of fingerings can be considered 'correct' and how, unless totally devoid of cogent thought, none can be truly considered incorrect.

Please read this book carefully and with all due diligence. Fully digest what you have gleaned from each article. Play through the musical examples with both the original as well as suggested alternate fingerings. Be sure you fully grasp why these examples are fingered the way they are. By doing so, you will incorporate the rationale into your learning and performance and gain the most from what has taken me years to cohesively arrange. Are my fingerings carved in stone? As I wrote previously, no! It is not the intent of the articles on fingering to demonstrate end-product; they were conceived to reveal the thought process one must engage in to produce a valid interpretive fingering for any given passage of music. An additional consideration is this: An 'easy' fingering might render a passage more playable but may be found wanting when the issues of interpretive issues come into play. Against this, one must consider the issues of stamina and strength. A series of difficult passages may be expertly executed in recital leaving the performer drained for the remainder of the program! One must marshal one's strength and stamina! One may find oneself arranging a program to incorporate 'rest' pieces, or reevaluating the fingering of a piece or pieces to wisely shepherd one's physical and mental reserves. So you see this process takes on extraordinary aspects!

Do not look upon this book as a collection of dry, lifeless dissertations on a number of dismal subjects. Freeing the utmost in timbre and emotion from our beautiful, sonorous instrument—the classical guitar—is a fascinating endeavor.

<div style="text-align: right;">
Harry George Pellegrin

Scotia, New York

January, 2011
</div>

Where *does* one find all those notes?

New students are perplexed by the guitar fingerboard. Unlike the piano, upon which all pitch/note names as well as exact register can be easily recognized once the pattern of black keys to white keys is established (which is usually accomplished in a matter of seconds); the guitar affords no visual cues.

Piano versus guitar:

The piano allows the student to easily see this:

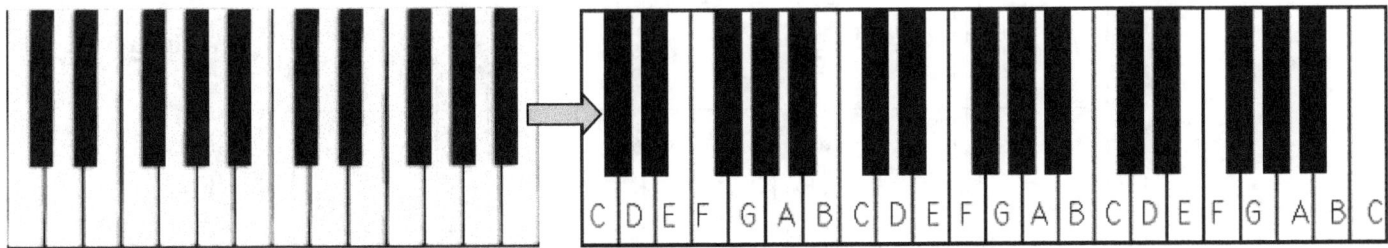

Whereas the guitar offers this rather uncommunicative aspect:

At this juncture, many a student will be feeling a bit fragile and wondering if some other instrument might be more to their liking! If he or she perseveres, the student is then taught the pitch names of the open strings and is often told that the instrument is fretted in half steps. With this rudimentary knowledge the student can figure out the pitch names of every note on the fingerboard—often incorrectly as the concept of sharps and flats and the basic layout of the western major scale are, at this early stage, beyond their ken. Many method books will include a chart intended to help the student and it will often look something like this:

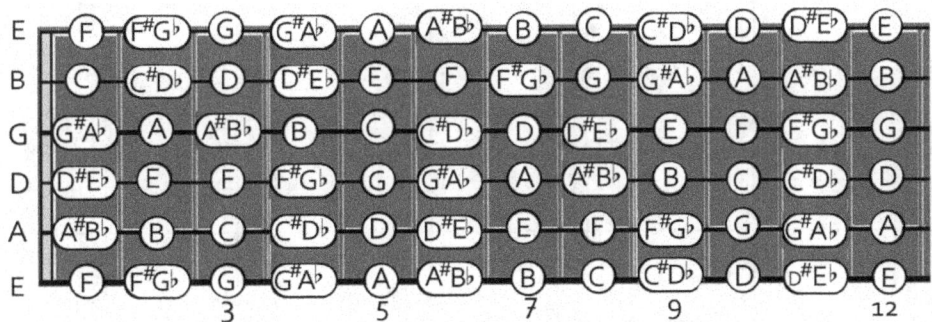

Now while good-intentioned and actually quite useful in some instances, this chart does not convey any information as to where the pitches are notated on the staff –indeed the student may be led to believe that, for instance, all A's are the same pitch and notated on the same line or space (depending on assumed register) on the staff! At least it reinforces the fact that A^b is $G^\#$, E^b is $D^\#$, G^b is $F^\#$ etc. The following chart indicates the pitches on each string at each fret in their correct registers and while less graphic in nature, is still more informative. (It is assumed that the student can read standard musical notation.)

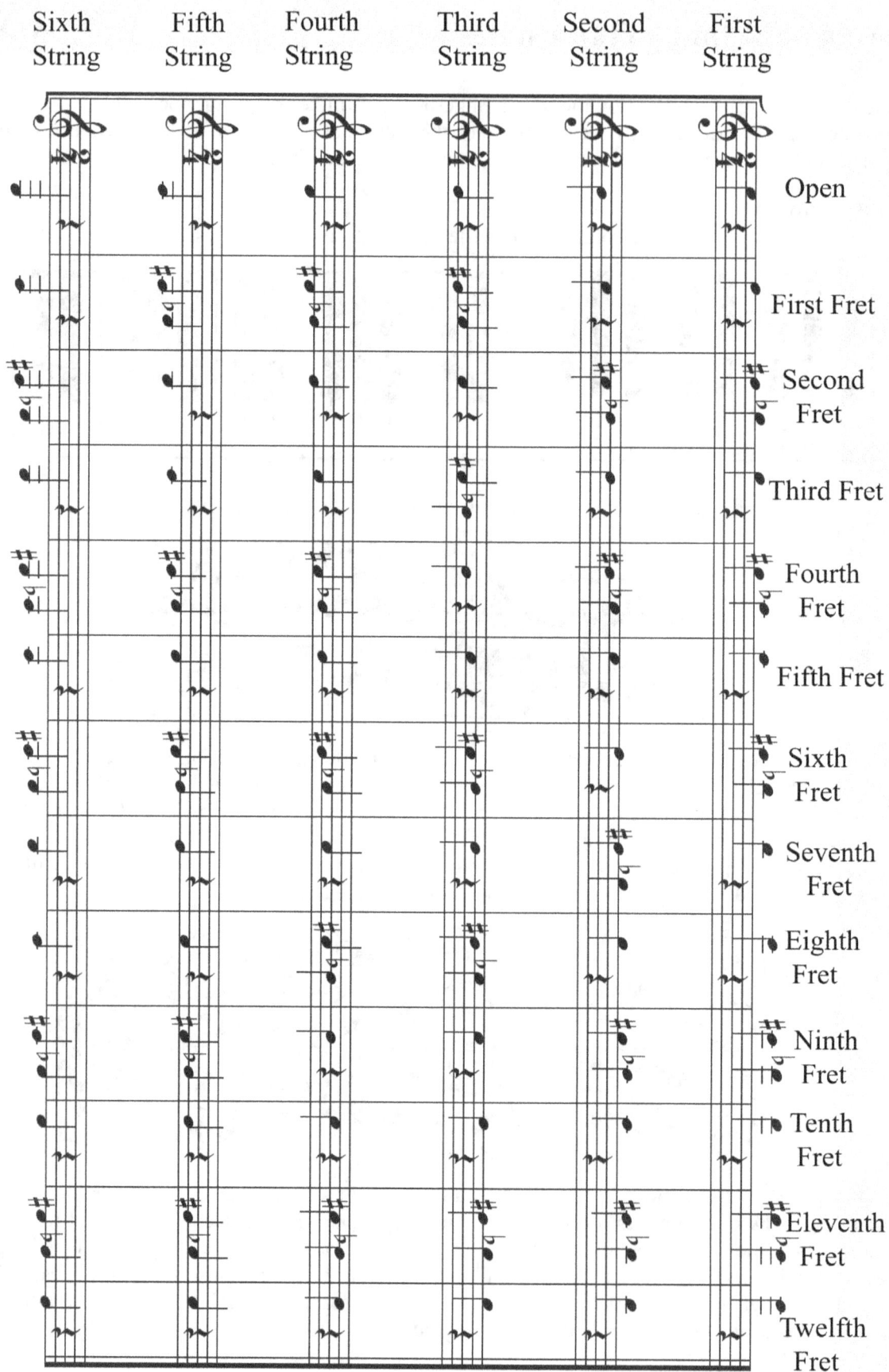

Unlocking the Fingerboard

There are two ways one can approach the memorization or the logic of the guitar fingerboard, one being in a horizontal fashion, the other being vertical. First the student must remember that the instrument is fretted in half steps and therefore if one can identify ONE pitch on any given string, one can correctly find other pitches by counting half steps in either the upward pitch duration or in the downward. This can and will be problematic for reading quickly though—especially if the student must count half steps on multiple strings—therefore it is a recommended mental exercise but not a method considered efficient for rapid sight-reading. The following diagram shows the first step in a linear (horizontal) manner of addressing basic pitch knowledge of the fingerboard.

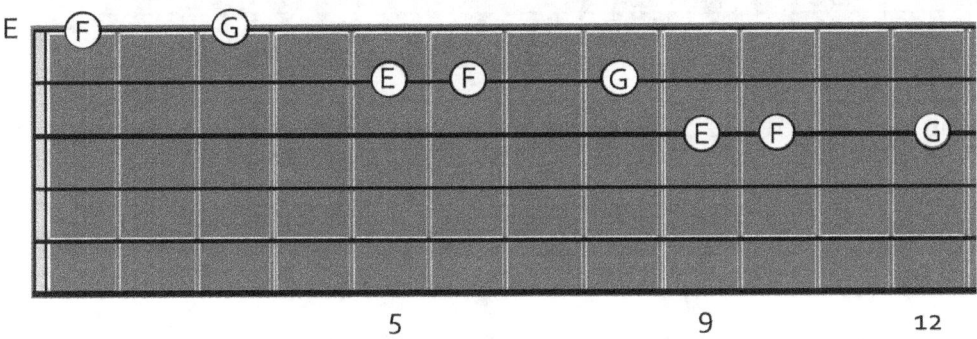

Most students learn the open position notes which include the open high e string as well as the f at the first fret and the g one whole step above that f, or the fretted pitch at the third fret on the first string. By remembering the 'tuning e' on the second string at the fifth fret, most students can easily grasp the fact that the e, the f, and the g on the second string will fall in the exact same pattern of whole and half steps as they did in the open position on the first string. The diagram above shows the e, f and g that are notated exactly the same way on the staff between the nut and the twelfth fret. Please note, all the indicated fretted pitches read:

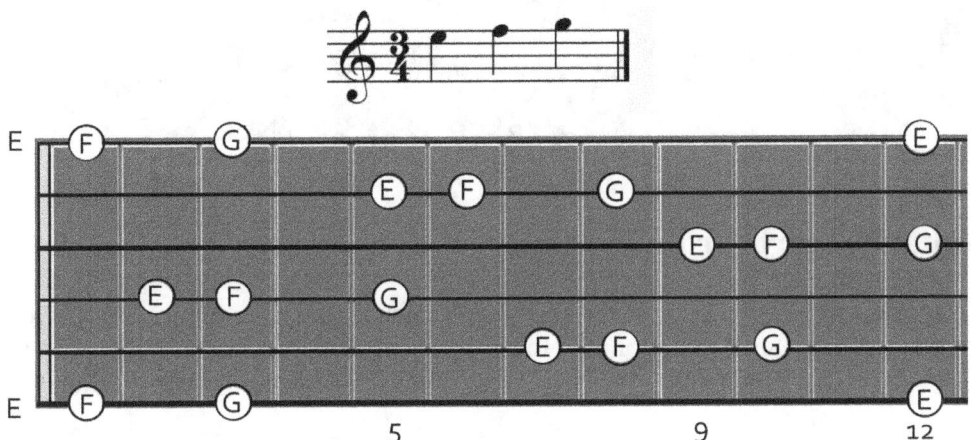

It is also not too much to assume that the student will then come to the realization that any time he or she encounters an e, regardless of register, an f and a g will follow in the exact same intervallic configuration. Directly above is an expanded diagram that include ALL the e's, f's and g's *regardless of register* between the nut and the twelfth fret. By string, this diagram would read:

Please disregard the rhythmic data in the chart to the left. It is there purely to appease the engraving software, not to indicate any prominence or emphasis.

Once the student can find all these repeating notes and understand where they fall on the staff, the fingerboard begins to open up. Next the student should find the following notes: b, c and d. See following diagram:

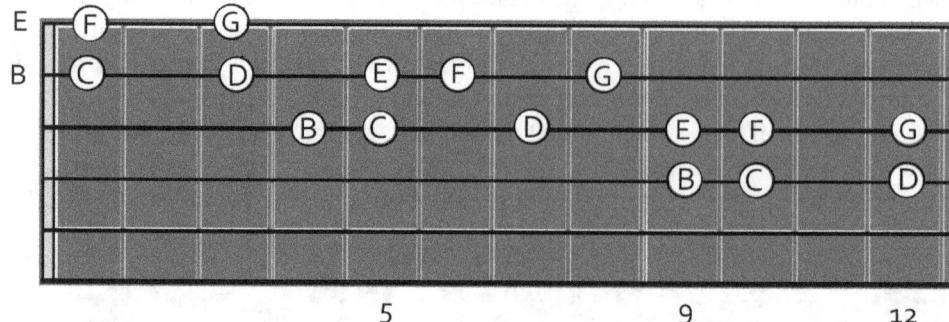

Once again, all the indicated B, C and D pitches are notated in and on exactly the same lines and spaces on the staff:

The student should note that much the same as the two half steps in the C major scale are in close proximity on the piano keyboard, so too the two half steps (E to F and B to C) are often found in close proximity on the fretboard. Please see diagram below. The entire fingerboard has been covered with a repeating intervallic pattern.

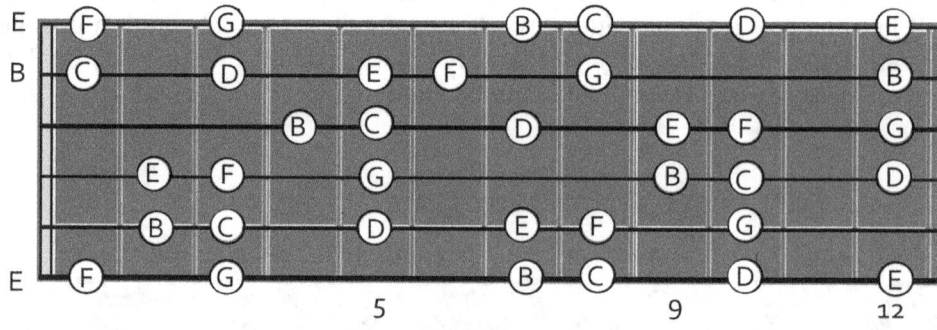

Reading, the Guitar Fingerboard & Intervals

The guitar fingerboard is laid out in half steps end to end. If you can count, you can read. If you can recognize the pattern that the intervals unquestionably form, you can read anywhere on the neck! Is this an overly radical statement? Not at all. Aside from the pitch/note names of the open strings, the student learns the following:

Tuning the guitar to itself:

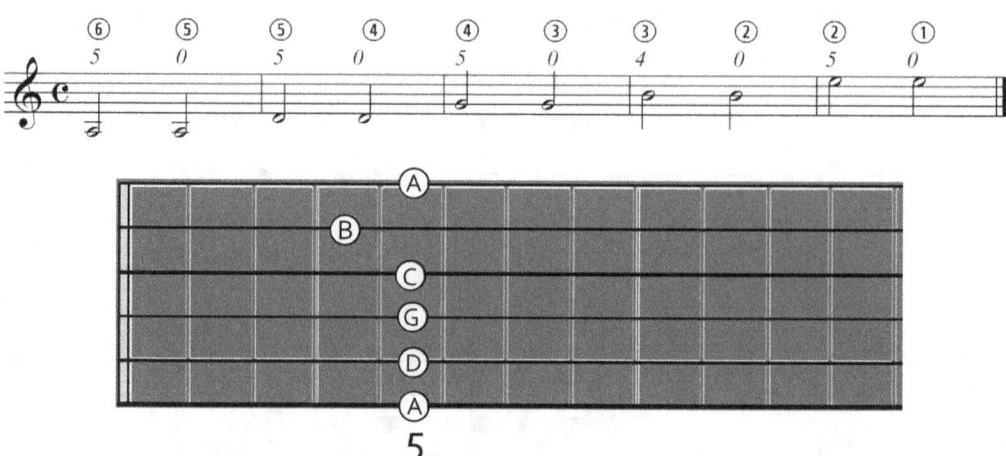

Let us begin at the fifth fret. Any guitar student who can tune the guitar to itself (or at least has been shown how to tune the guitar) by utilizing the 'overlapping' tones at the fifth fret knows the pitch names of the notes located on the fifth fret. (See the example above.) As a recap, here is the process. Depress the sixth string at the fifth fret. The pitch produced is the same pitch as the open fifth string. Okay. You know full well that the open fifth string's pitch is the A below middle C (two ledger lines below the treble clef staff.) So far, so good. The fifth fret of the fifth string produces the same pitch as the open fourth string. Ditto until you get to the third string/second string. The second string open is tuned to the fourth fret of the third string (a major third above the fourth string.) Things return to normal when tuning the first string from the second. The fifth fret of the second string produces the E note that is the top space of the treble clef staff, which is also our open first string. Knowing this yields the following chart:

Fifth Fret Notes

We can draw a few valid conclusions simply through common sense. Look at the chart of notes on the following page. The odd number measures (first measure, third measure, fifth measure, etc.) show the open string notes as demonstrated in almost every guitar method book. The even measures show these same notes on the corresponding strings from the fifth fret up. In other words, that E, F, and G played on the open first and third frets of the first string are played on the fifth, sixth and eighth fret on the second string. The same half and whole steps are present with E, F and G no matter where they are played. We will use the term *Reading Overlap* to describe this principle.

The guitar (as well as the other stringed instruments) has a distinct disadvantage when compared to the piano. On a keyboard, a note on a specific line or space of the staff can only be played with one key. When the pianist sees an 'e' written in the top space of the staff, he or she immediately places a finger on one key and there is no confusion. The fretboard of the guitar has a number of areas of overlap so that the same written note might be played in three different places. What chord or melody surrounds the note (as well as tone-color considerations) will decide where the note will be played. The following is a very basic diagram of the notes in "open" position contrasted to the fifth through tenth fret notes the student has learned already. At this juncture we return to the notes the student knows at the fifth fret (but may not realize he or she may possess this knowledge for this purpose.) These are mostly all the 'tuning notes'. Fretting the sixth string at the fifth frets yields the A pitch of the fifth string, etc. Please note: The fretted pitch at the fifth fret on the third string does not yield the pitch of the open second string as it is at this string-to-string juncture we have the interval of the major third so in the accompanying diagram we see the fretted pitch 'c' at the fifth fret of the third string. The student will realize that the correct fretted pitch for tuning purposes is the 'b' one half step below at the fourth fret of the third string. Thus begins a vertical knowledge of the fingerboard.

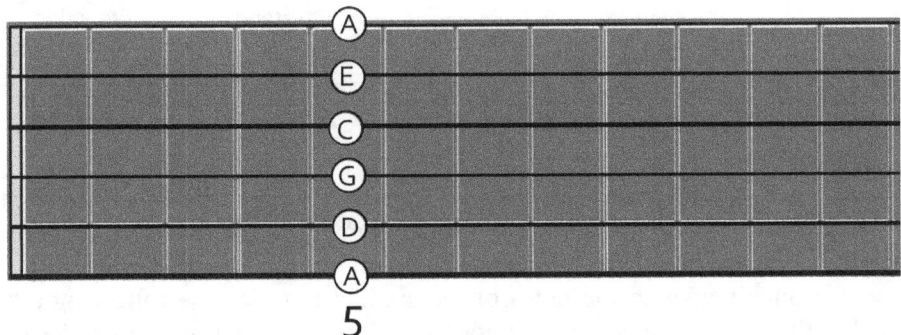

This simple knowledge can be built upon—the student can easily add the necessary whole step to the fifth fret pitches to successfully ascertain the notes at the seventh fret, and this is the second means by which one can

unlock the fretboard. The previous method, building from the simple e, f, g and b, c, d pitches builds the knowledge in a linear manner; this method builds the knowledge in a 'vertical' fashion. The following diagram demonstrates the whole step increase from the fifth fret to the seventh fret:

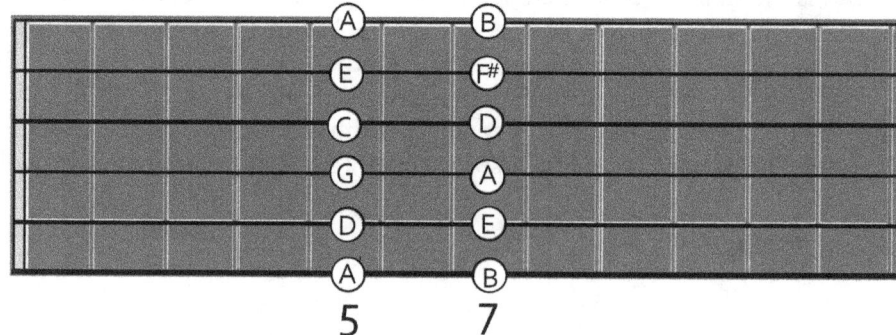

By adding the notes at the twelfth fret (one octave from the open pitches) the student can find notes within a step or two proceeding down the fingerboard and arrive at correct fretted pitches at the ninth fret:

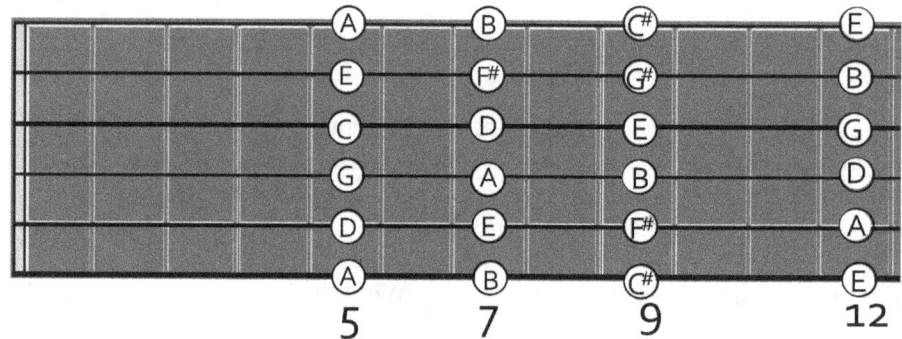

By combing the linear with the vertical knowledge, the student should be able to figure out where certain pitches lie with a small degree of facility—not quickly enough to sight read in performance, but by repeating the process as he or she (with guitar in hand) learns exercises or repertoire, the locations and intervallic certainties will become engrained.

Reading Overlap

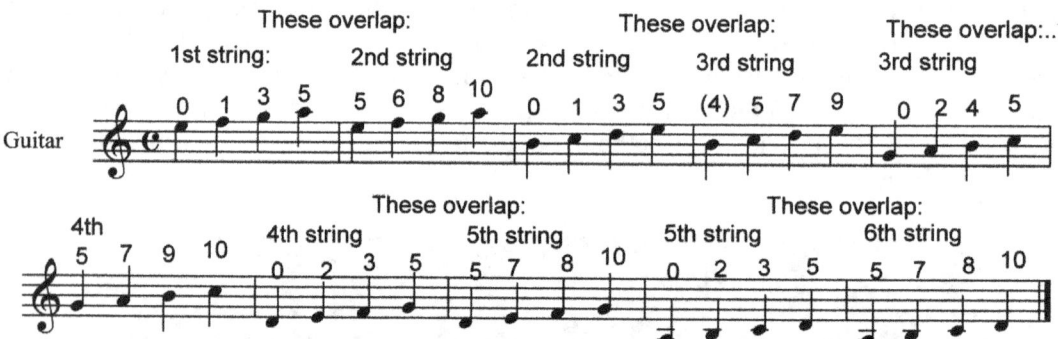

Now let us assume that the student has learned his Grand Barré chord based on the E major open position chord—the Barré chord that makes an F major at the first fret, a G major at the third fret, an A major at the fifth fret and so on. Here is the gist: If the student knows this chord and can use it to generate chords up and down the neck, he or she already knows the pitch names of the notes of the sixth string. See the following example. The student may not have realized that these pitch names were notated as follows, but now he or she does! As the author explains to his students, if you can tune your guitar to itself using the fifth fret/open string method, then you already know the notes of the fifth fret across the neck. See the A note on the fifth fret in the diagram? That's the A open

string note as well—notation-wise as well as pitch-wise. This knowledge incorporates both horizontal as well as vertical knowledge of the fingerboard.

If the student knows the pitch names of the notes of the sixth string, the first string is readily understood and memorized. Of course, it will be notated *two octaves above* the sixth string. (See the example below.)

The First and Sixth Strings in Comparison

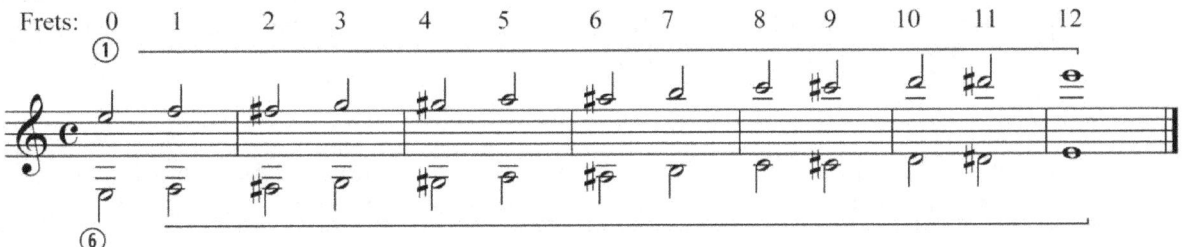

The student should now know the first and sixth string notes. "But," the student asks, "I can't read the strings in between! What do I do?" As mentioned previously, for the most part, the guitar is tuned in fourths. We will now look at some basic theoretical harmony, then look at intervals in order that they assist in our reading quickly and accurately.

Rudimentary Harmony

The harmonization of the major scale is a cornerstone to understanding the analysis of chord structure in most compositions of Western music. Students are often mystified that certain chords are major and some minor in a piece they are learning. If the piece is in C Major, how can there be an F Major chord and a G Major chord? Surely G Major has an F sharp in its key signature, F Major a B flat? This is a reasonable assertion, incorrect as it is. But how does this work? Music is purely logical – at least from the theoretical aspect. Once the basic concepts are understood, the mystery is removed.

To understand how the scale is harmonized, one must understand how chords are constructed. To have a true chord, one must have no less than three individual and discrete tones or notes. This construction is known as a TRIAD; triad obviously based on the root word 'tri' signifying 'three'. Two notes can, and often are, used to imply a harmony. Implication though is not a definitive statement. The tonality of the simple triadic chord (i.e.: major, minor, diminished or augmented) is arrived upon by the quality of the intervals contained therein. So we must identify what intervals are present and how they are arranged or "stacked."

First let us look at the C major scale. By now the student should know exactly where the whole steps and half steps fall in the scale. This knowledge is crucial as it tells us what intervals lie between each note and each spread of notes. Steps are included by way of review.

As one can readily see, if one jumps from C to E, the interval created is comprised of two whole steps. An interval of two whole steps is most commonly referred to as a MAJOR THIRD. (Similarly, if one starts on A and jumps to C, it is readily apparent that the interval created is comprised of a whole step and a half step. This interval is one half step smaller than a Major Third; it is referred to as a MINOR THIRD.)

Knowing the quality of thirds; major or minor, allows one to determine the major or minor tonality of a chord *without hearing it*. A picture is worth a thousand words so let's build some chords.

 Three and one half steps is the intervallic distance for C natural to G natural and denotes the interval known as the **Perfect Fifth**, the most tonally stable intervallic relationship after the unison and the octave. These two notes can often imply a tonality depending on their treatment, but can never unequivocally denote a major or minor chord.

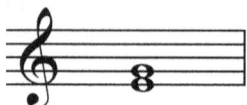 One and one half steps, the intervallic distance from E natural to G natural, most commonly referred to as a Minor Third. Once again, although they can imply a minor tonality, they cannot guarantee it.

 Spanning three and one half steps, with a minor third stacked atop a major third, these three notes, C natural, E natural and G natural are universally accepted as a C Major triad.

 Building a Minor Triad, we start with the interval of one and one half steps, the minor third.

 Placing a major third (an interval of two whole steps) above this minor third (left) once again results in the intervallic span of a perfect fifth (right).

 The minor third/major third stack—adding up to a perfect fifth—results in the correct assembly of a minor triad, in this case E minor.

Let us go back to the scale, this time harmonized by stacking thirds:

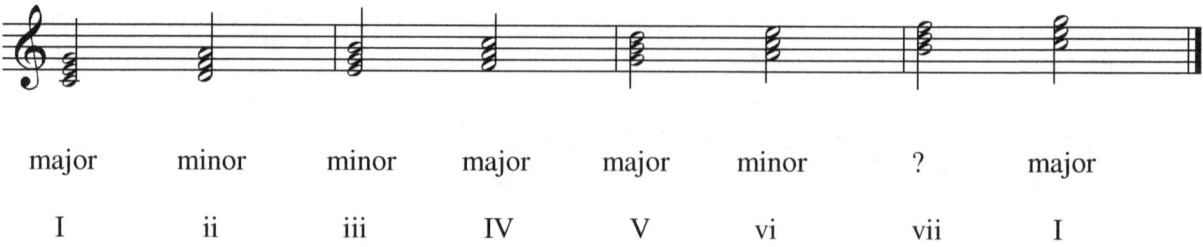

major	minor	minor	major	major	minor	?	major
I	ii	iii	IV	V	vi	vii	I

Above we see the most common harmonization of the major scale. The Roman numerals denote the shorthand most musicians use to indicate the standard harmonization of the scale step; I being the tonic of the key signature, V being the dominant chord, etc. Please note the question mark at the seventh scale tone. Why have I noted this chord in such a manner? Count the intervals. B to D is a minor third (one and one half steps) and D to F is a minor third (one and one half steps) adding up to three steps: not the three and one half steps required for a perfect fifth. We have a fifth that is short by a half step. What is this? A **diminished fifth** (called a **tritone**) an interval some consider one of the most dissonant in western music. For this reason, the chord is named for this dissonance and is referred to as a diminished chord.

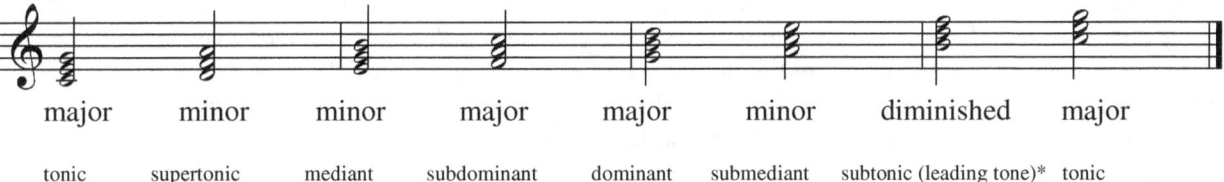

major	minor	minor	major	major	minor	diminished	major
tonic	supertonic	mediant	subdominant	dominant	submediant	subtonic (leading tone)*	tonic

*Chord is referred to as the subtonic if the root of the chord is a major second below the tonic. If the chord's root is a minor second below the tonic, it is referred to as a leading tone triad.

Western music revolves around the **tonic/dominant relationship** and the overwhelming majority of pieces can be analyzed and distilled down to the **I – V – I** progression of chords. This is a *stable to tension, release-to-stability* arrangement. By understanding this simple principle, it is easy to guess that a piece in the key of C major will contain a C major chord/tonality that is offset by a G major (dominant) or G major dominant seventh chord that will ultimately resolve to C major regardless of what other tonalities may be visited or even implied by the other structural elements.

Common Intervals and Their Patterns

The most resolved interval (the ear sense no need for any type of resolution such as with a seventh or second) is the unison or the same exact pitch played on two different strings such as the E on the fifth fret of the second string and the open first string. The Octave, two pitches separated by five whole steps and two half steps, is the next most resolved interval.

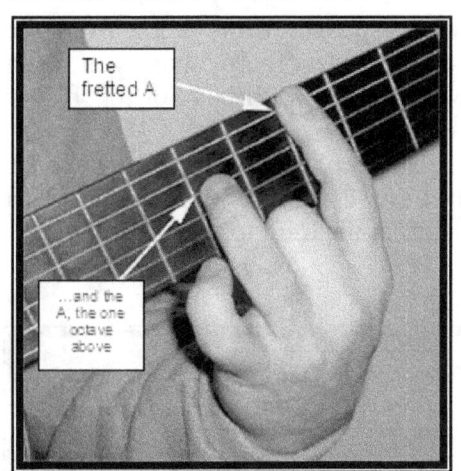

To play an octave (photo at left), one places the first finger on a note on any string and the third finger on the string two strings higher, two frets above the first fretted note.

The **Perfect** intervals, the perfect fourth and perfect fifth are the next most resolved, with the fifth being the more resolved of the two. The perfect fourth is the interval between the open E and A, A and D, D and G, and B and E strings. The perfect fourth can also be found across the fret on adjacent strings, in other words, the note fretted on the sixth fret of the fifth string is a perfect fourth above the note fretted on the sixth fret of the sixth string.

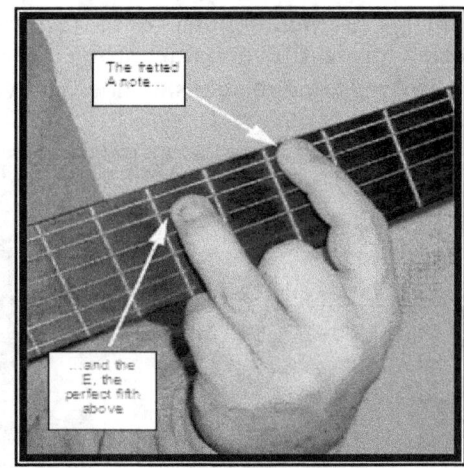

To play a perfect fifth (photo to right), one places the first finger on a note on any string aside from the third string and the third finger on the next string higher, two frets above the first fretted note. See photograph. Play a fifth and listen to the two notes and their interaction.

Examples of Octaves: The Sixth and Fourth Strings

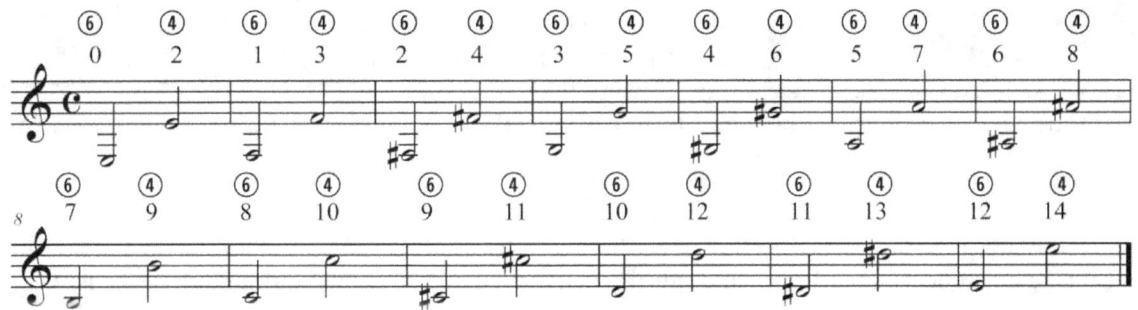

Now, as you'll remember, the perfect fourth interval is the intervallic relationship between the sixth and fifth, fifth and fourth, fourth and third, and second and first string. [The fourth is 'less perfect' than the fifth, being a little less stable theoretically.] I have generated a chart (to be found on next page) showing the notes on the fifth string adjacent to our root notes on the sixth string. The thing to remember is this: If your finger is fretting the C note on the ninth fret of the sixth string, the F note one perfect fourth above will be located on the exact same fret on the fifth string. (See chart.)

Examples of Fourths: The Sixth and Fifth Strings

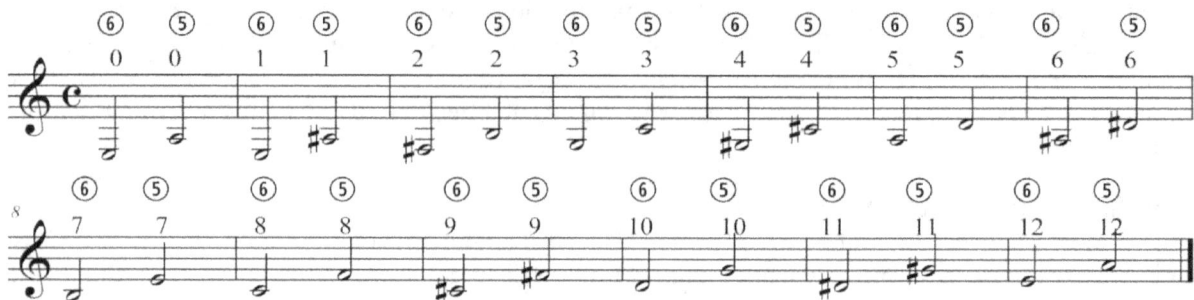

Here is the basic rule for intervals of the octave, perfect fourth and perfect fifth—aside from the relationship between the third and second string, if your first finger is on a fret, the perfect fourth above will be on the same fret of the next adjacent string. If your first finger is on a fret, the perfect fifth will be two frets higher (played with the third finger more than likely) on the next adjacent string.

If your first finger is on a fret, the octave will be two frets higher (once again, played with the third finger) skipping a string. In other words, the octave is sixth string fifth fret and fourth string seventh fret. It is simple. This works for the fifth and third string, but due to the aforementioned intervallic shift at the third to second string, this finger/fret/string relationship does not work past the fifth/third string.

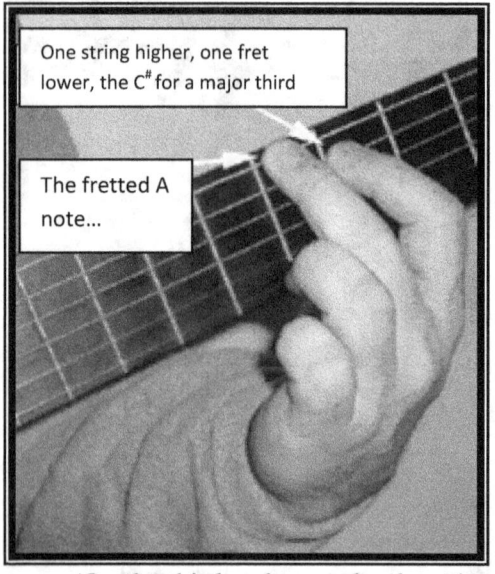

To play a Major Third (photo at left), place a finger on a note and another finger on the note one stringer higher and one fret lower than the first note (except, as noted elsewhere, with the third and second string. With the third and second string, the major third falls on the same fret.)

To play a Minor Third (photo at right), place a finger on a note and another finger on the note one stringer higher and two frets lower than the first note. (On the third and second string, the minor third is fingered like a major third on any other two strings.)

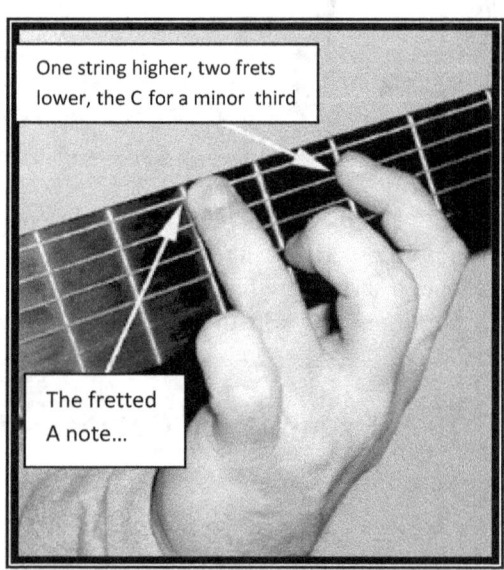

The following page of examples illustrates the Perfect Fourth and Major and Minor Thirds on the fourth and third string. The student should play through these listening to the interval simultaneously getting a feel for the pattern and to accustom the ear to the sound of the interval.

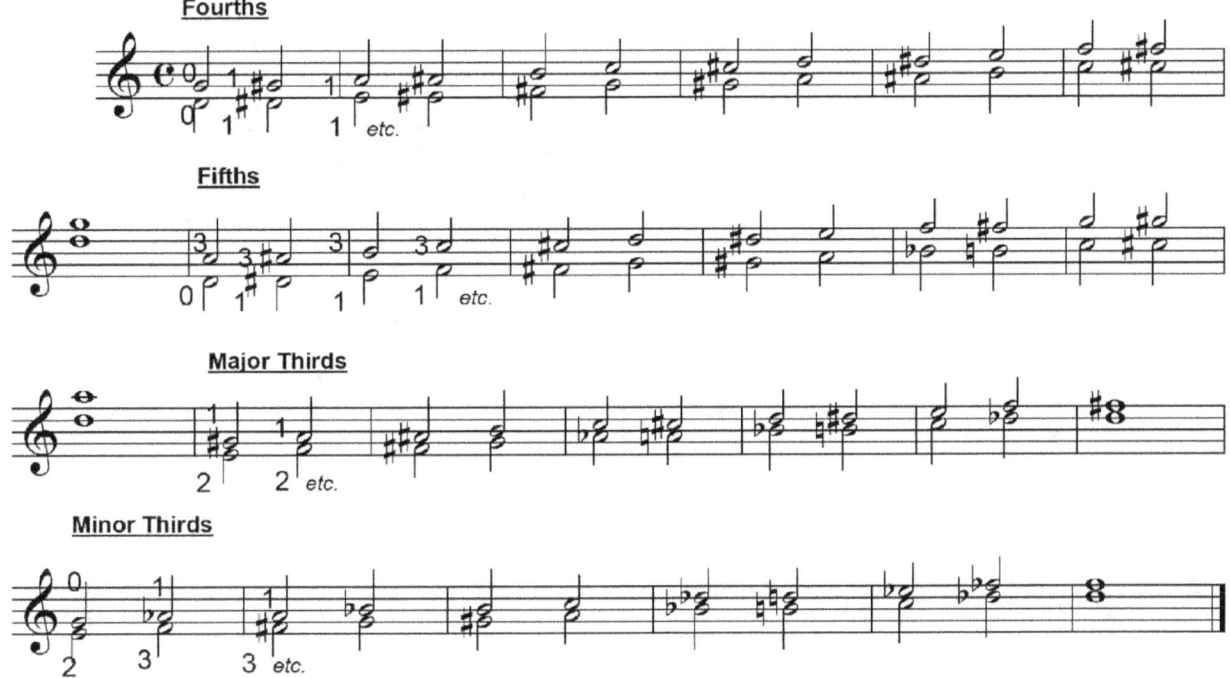

Patterns: The first milestone on the Road to proper fingering and the key to unlocking the guitar's fingerboard is to realize that all scales, intervals and chords are *patterns*. Once the guitarist has determined where the composer or transcriber has placed a chord or melody, he or she can generate the pitches by knowing where intervals are situated on the fretboard.

Look at the examples above. Let's examine the perfect fifth. If one were to see an E (first line of staff) and then see the B note (middle line) written either above or adjacent to it, the well-studied guitarist should put his first finger on the E on the third fret of the fourth string and third finger on the third string at the seventh fret. It should be almost instinctive. Similarly, the perfect fourth is simply formed by utilizing the two notes at the same fret on adjacent strings (except between the third and second string which we will look at later.)

The interval of the third comes in two varieties—a major and a minor. The major third is built by placing one whole step atop another whole step. (C to D = one whole step, D to E = one whole step, so C to E = two whole steps or a major third.) The minor third is one half step smaller; in other words, it is built from a whole step with a half step placed atop. (A to B is one whole step; A to C is one half step, so A to C is one whole and one half step and therefore a minor third.)

The Perfect Fifth

Sixth and Fifth Strings:

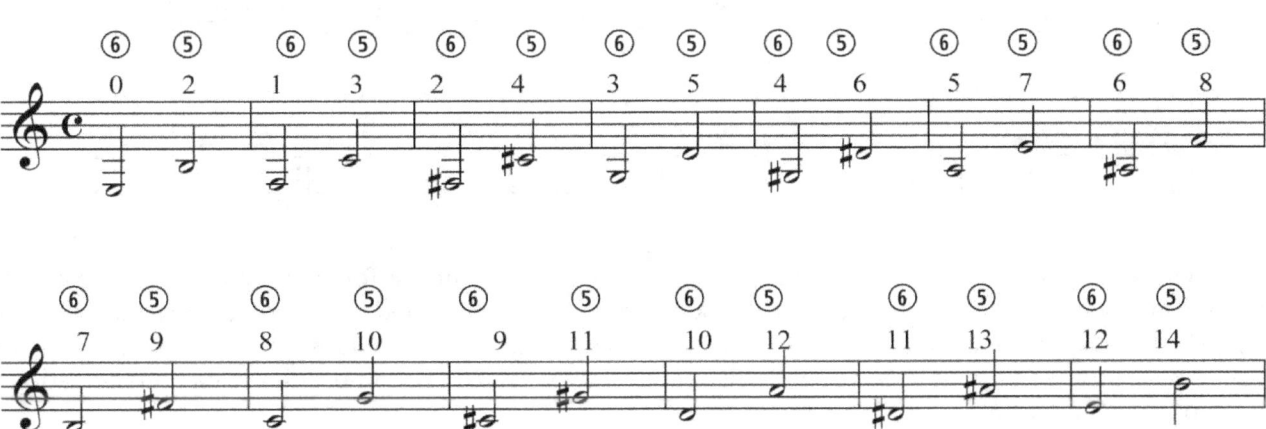

Fifth and Fourth Strings:

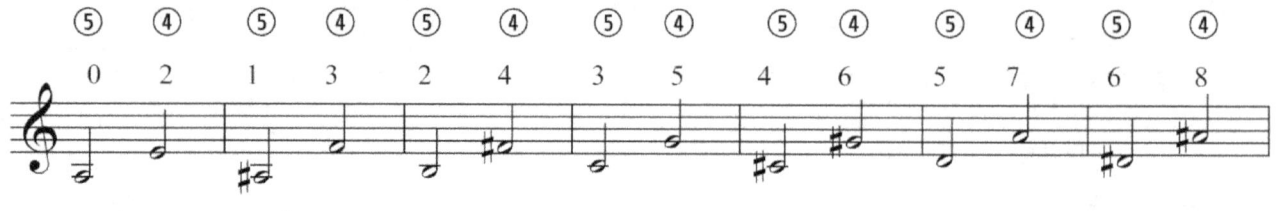

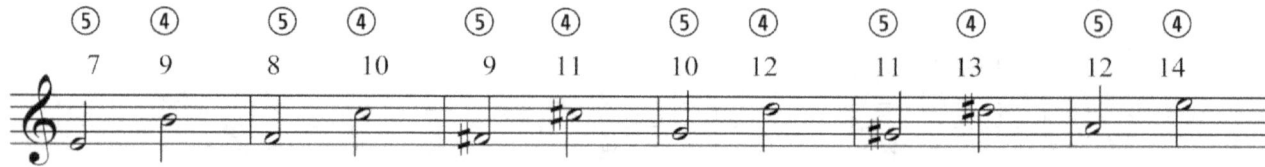

Fourth and Third Strings:

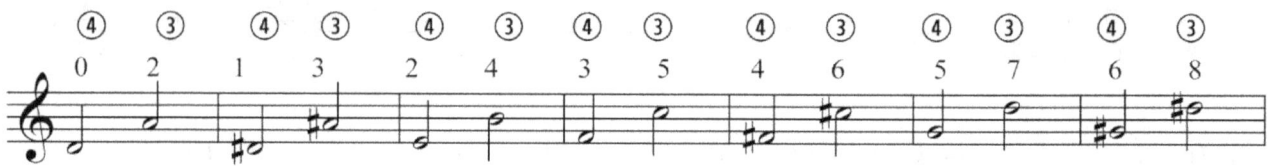

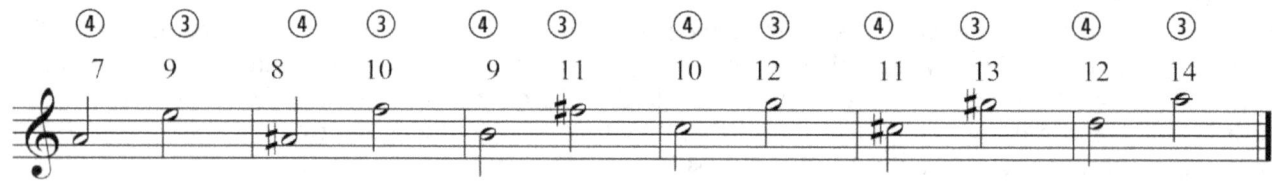

Proceeding to the more horizontal realm, we find that scales are almost always found to form recognizable patterns. Below is a c major scale that all student guitarists learn. The circled numerals indicate the string upon which the note will be found, the plain numbers represent the fingers used to fret the pitches.

Two Octave C Major Scale. Use same pattern for B, C#, D, E♭, and E major as well

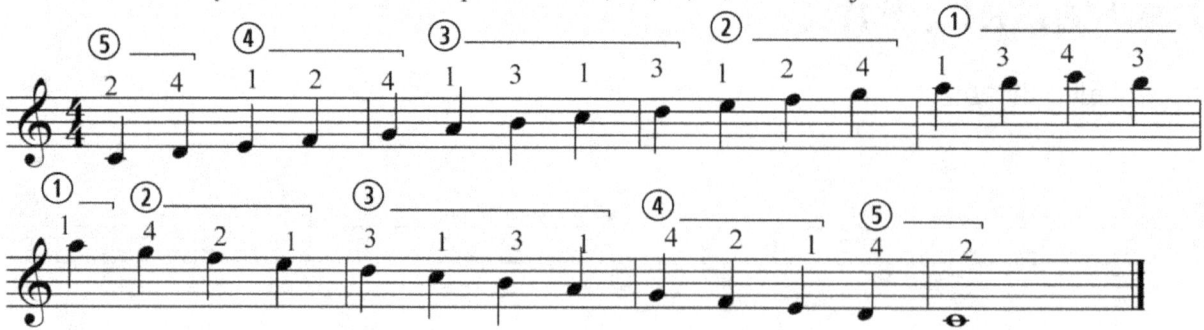

The scale can be interpreted as the fretted pitches indicated in the following diagram: (Please note the position shift on the third string between the b and the c (third finger on the fourth fret to first finger on the fifth fret.) Although the c could have been fretted with the fourth finger, this would have lent an air of finality to the scale—the position shift to the first finger is highly indicative of a change on position with a continuation of the scale into the second octave.

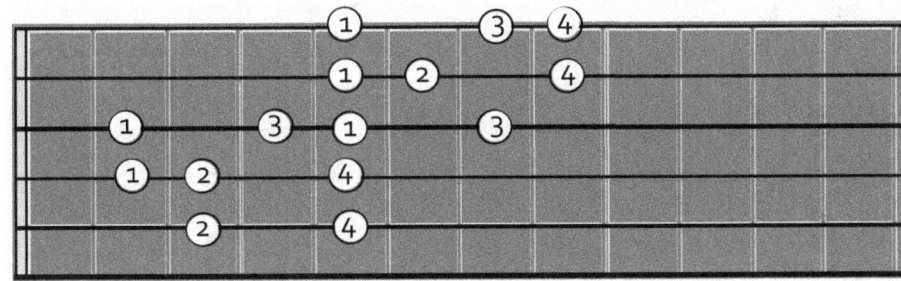

The scale can be broken into two segments by position; the first octave thusly:

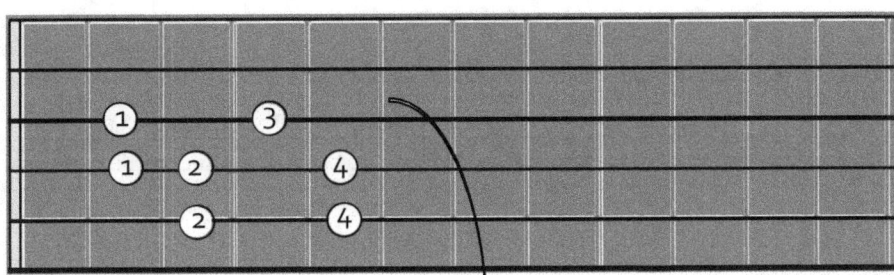

This ends the scale in the primary position on b, or the leading tone. The first octave is actually completed by the first fretted pitch of the secondary position beginning the second octave:

I often call this moveable pattern scale a 'paint-by-numbers scale' as the student only needs to know the tonic note and where to find it to generate the scale in a number of keys. As this leads the student to assume that it is not necessary to 'know the notes', I insist that the student speak the pitch names out loud as he or she plays the scale in the more common 'guitar keys'. [C major, D major, G major, E major, and A major.] In other words as the C major scale is played the student will be saying "C, D, E, F, G" etc. and when playing D major, will be saying "D, E, F sharp, G, A, B C sharp"… etc. This does not tell the student *where* the pitches are notated on the staff but the student will at the very least become cognizant of the pitches being produced. When the pitch names become rote, the spoken part of the exercise has become superfluous and can be discontinued.

It is considered rote knowledge, but the guitarist should remember that relative majors and minors contain the same scale fragments. The major scale contains the natural minor form of its relative minor; the minor scale contains the relative major scale. We will examine the F major scale and its relative minor, d minor. I use the melodic forms of the minor scale because as performers upon a melodic instrument, that scale is the one we will most often practice. See the following examples:

F Major

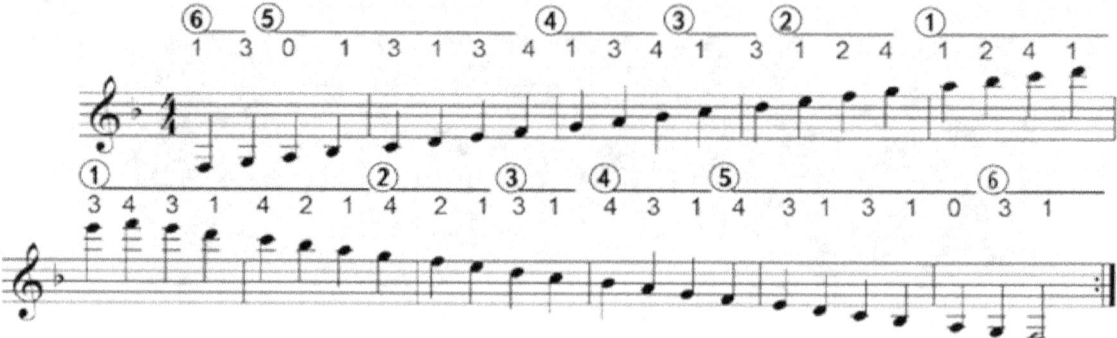

D melodic minor

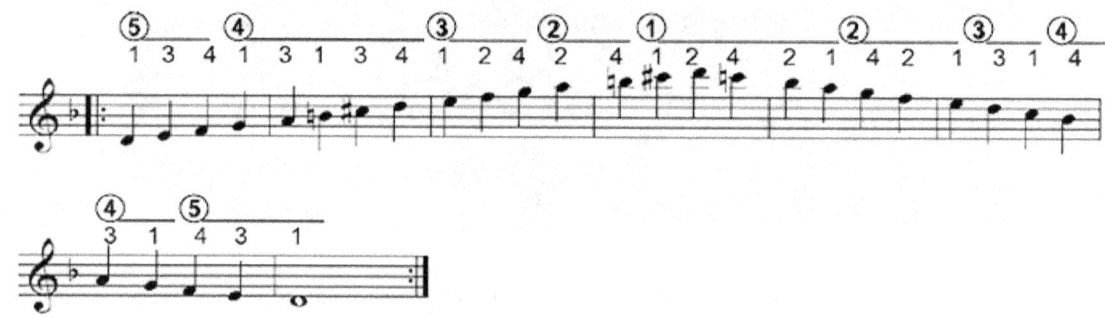

For the purpose of clarity, I have highlighted the similar portion of the two scales. Please note that not only are the notes identical, the fingering used to execute that portion of the scale is identical as well.

F Major

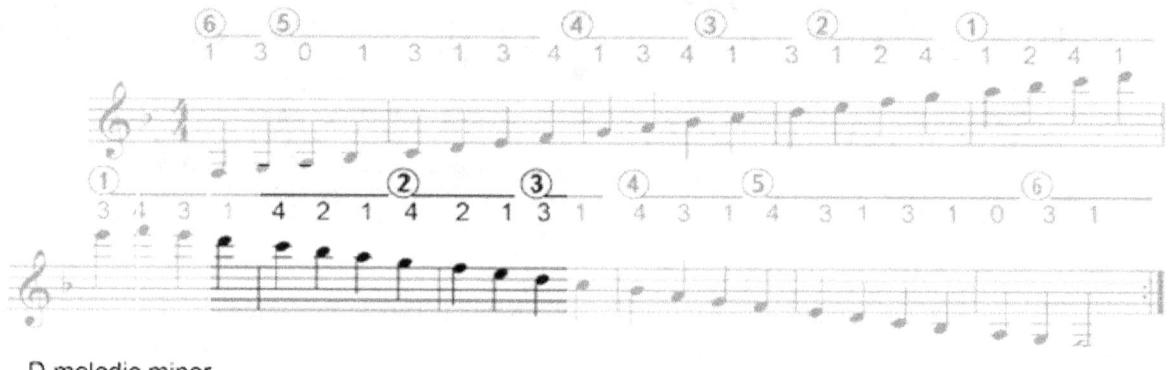

D melodic minor

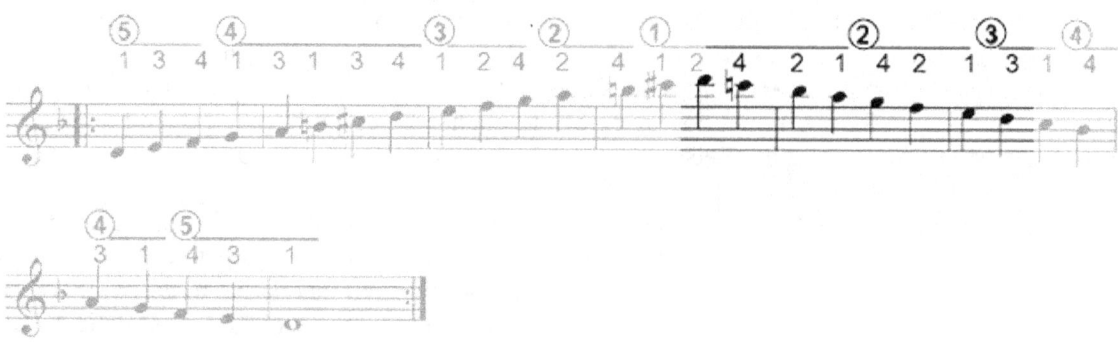

The next three pieces are included in my ***Classic Guitar Method*** and are intended to review the notes learned at and surrounding the fifth fret, compare them to the identically written pitches in open position—plus give the hands a bit of training with familiar melodies. Observe how the same pitches are played in different positions. Make note of timbral variety as well as ease of fingering and the ability to transpose the key of the melody with relative ease when playing the fifth fret position pattern.

Lightly Row

Folk Song

Fifth Fret Position

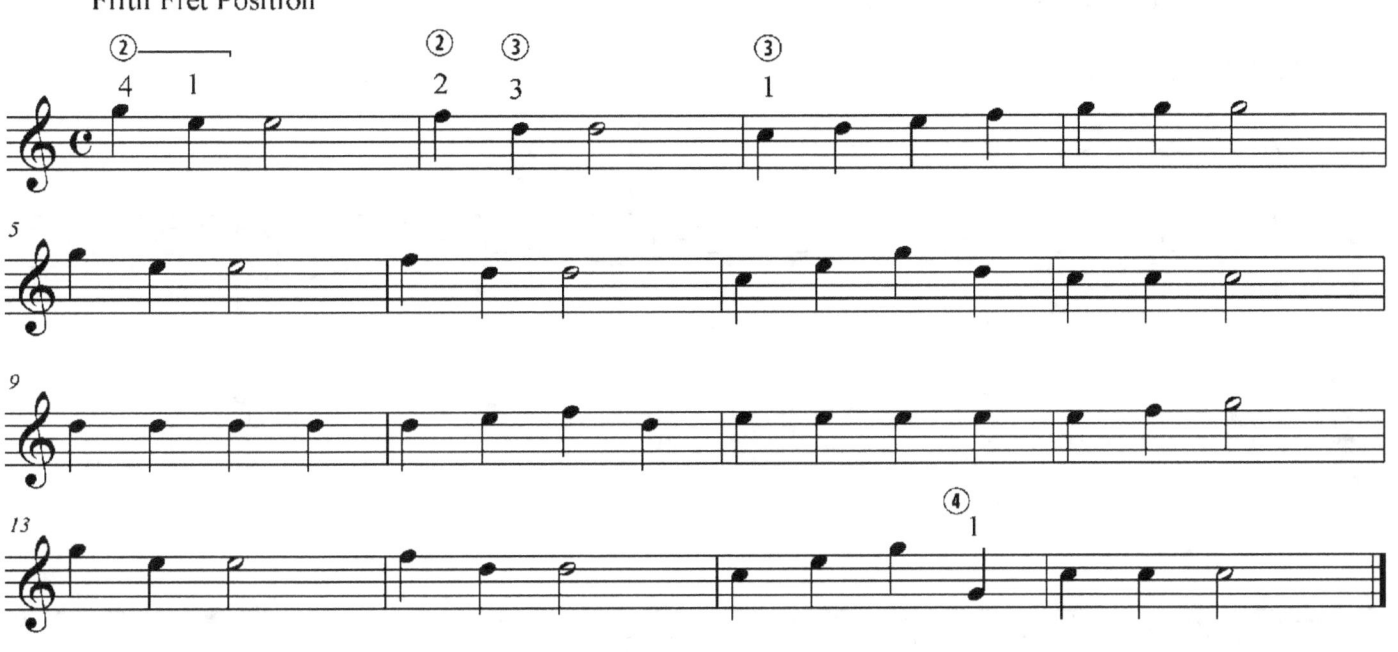

Open Position

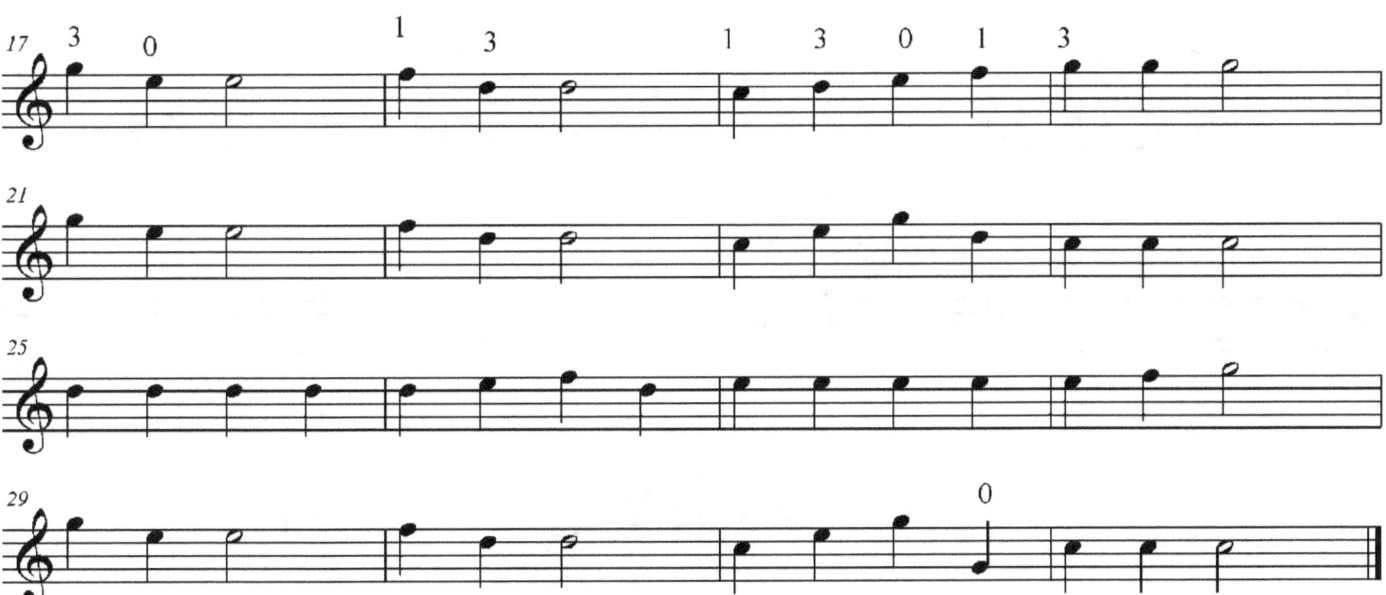

Go Tell Aunt Rhody

Fifth Fret Position

Folk Song

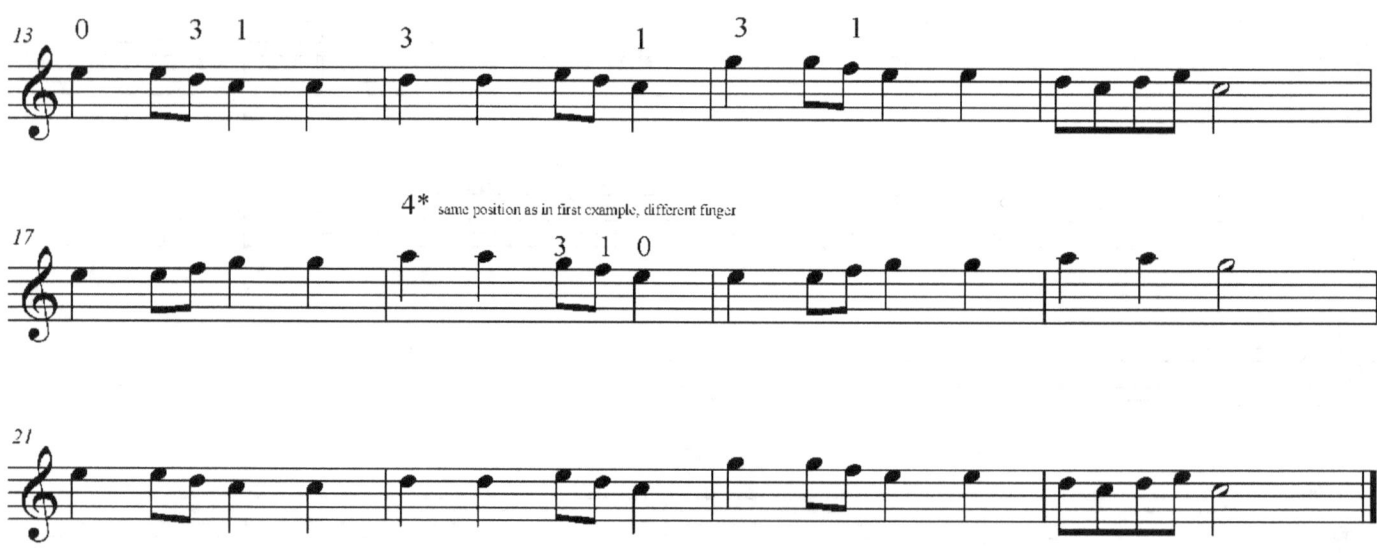

Long, Long Ago

T.H. Bayly

Fifth Fret Position

Open Position

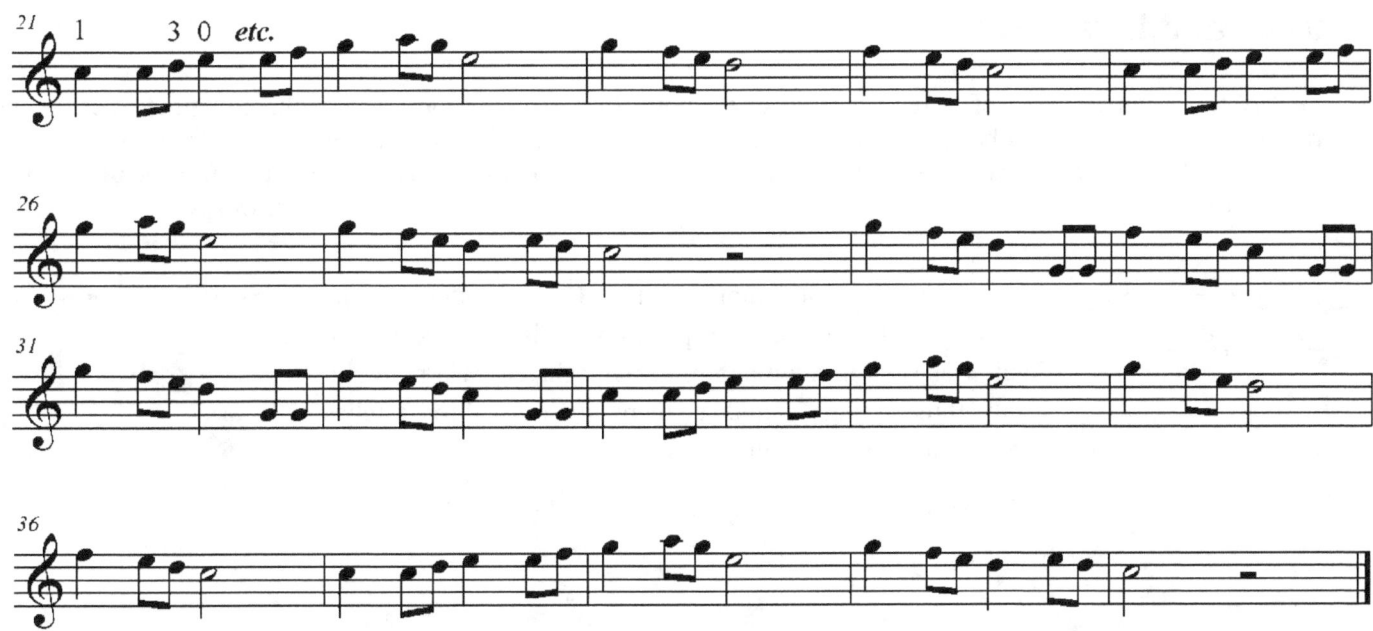

Another hindrance to good sight reading skills is one of rapid interpretation of a measures' worth of data. As the student gains confidence, he or she will begin to read music in much the same manner in which we read the printed word. When small children are learning to read, they are not readers merely because they know the alphabet. They must look at each letter in a word, determine what sound it produces, then string those sounds into a coherent syllable or syllables and then determine the meaning of the complete word. As the students' ability and speed increase, the process smoothes. Instead of seeing each individual letter while consciously making the letter sound mentally, then stringing these together to (hopefully) form a word, the reader sees the entire word and interprets it. An experienced reader sees the word 'CAT' and doesn't see three individual letters; he or she doesn't even see the word per se—it is an image of whiskers and a tail that immediately come to mind. Scale passages, unless fraught with chromaticizms, are easiest to read quickly. The student learns to observe from whence to where the scale passage progresses and checks for any gaps (intervallic jumps). Not so easy to interpret correctly are arpeggiated chords in inversion. Let us discuss an arpeggio of an a minor chord in first inversion. The student sees a 'c' as the lowest note and through a quick scan sees another 'c' and maybe an 'e'. The left hand automatically jumps to a C major hand shape. Due to the relative major/minor relationship between the two chords the mistake may go unnoticed. For this reason, the first article to follow this page is a brief overview of chord inversions.

The next milestone on the road to proper fingering requires the student to understand how chord forms in root position or anyinversion—and by this my intent is to indicate left hand shapes—are constructed and how one moves from one hand shape to the next. I refer to this motion as shape transitions—or simply *transitions*. Much of the repertoire involves the guitaristic phenomenon of gleaning a bass voice, an accompaniment, and a melody line from a left hand shape that can be thought of and identified as a chord shape. [Please see the article 'Learning a New Piece' later in this volume.]

Motion from one shape to the next is where most guitarists lose time and expend energy unnecessarily. Transitions need not include a total rearrangement of the fingers but a careful assessment of the transition will quickly indicate to the astute student any commonalities: Do any of the left hand fingers remain on the same fretted pitches? Does one (or more fingers) merely slide a specific distance on the same string? Does one (or more fingers) simply move to an adjacent fret? This forethought and knowledge allow the player to economize motion thereby saving time and marshaling stamina.

Chords and Inversions

A chord must consist of at least three discrete notes (a triad). Without at least three distinct pitches, one merely has an interval and although a complete chord may be *implied* by the interval, it is neither a sonic nor a theoretical certainty. The arrangement of these three pitches determines whether the chord is in **root position** or one of its **inversions**.

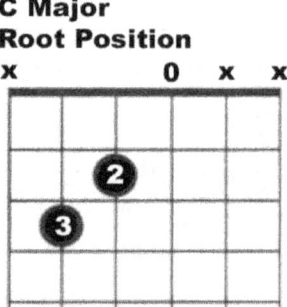

C Major Root Position

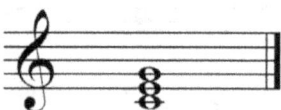

C major root position chord notated. C, the root note of the triad, is in the lowest pitch position. It is fingered on the guitar as seen in the diagram to the right. Please note that only three strings sound as there are only three pitches represented in the notation.

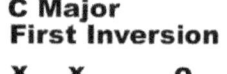

C Major First Inversion

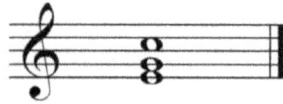

C major first inversion notated. E, the third of the chord, is in the lowest pitch position. If that E were placed an octave below (beneath the third ledge line below the staff) it would still be a first inversion chord.

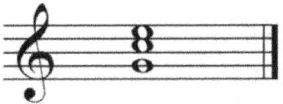

C major second inversion notated. G, the fifth of the chord, is in the lowest pitch position.

Please note: While these three notated chords look different on the staff, are fingered differently on the fretboard and even sound different in comparison, they are still C major triads. Although arranged in different manners, each contains the Perfect Fifth, the Major third between root and third and the minor third relationship between the third and the fifth. These chord forms are used by composers and transcribers to evoke a mood through variance in timbre, aid in voice leading, or to facilitate the performance of a passage.

The following article, *Assessing the Relationships of Chord Forms*, was first printed in the third edition of **Classic Guitar Method**. It describes how most left hand shapes are based on some very common and repeating fretted-pitch/finger relationships. That is, the hand shape that generates a c major chord in open position is only slightly modified by increasing the distance between the left hand fingers to produce a G^7 chord in open position: the second and third fingers move from the fourth and fifth strings to the same frets on the fifth and sixth strings while the first finger moves from the first fret of the second string to the first fret of the first string. The hand shape is identical aside from the increase in 'spread' between the second and third and the first finger. Most new students when making this transition remove all fingers from the fretboard and then searches for the new notes—a waste of time and mental energy. This is described at length in the article and is expanded upon to include a variety of common left hand shapes along with common inversions thereof as well as common transition to and from them.

Assessing the Relationships of Chord Forms

Two of the major impediments to the guitarist are a lack of time and a lack of stamina. Stamina is one's ability to continue to perform through difficult or lengthy passages without tiring to the point of failure. Time here is meant to indicate the time necessary for the transition from one hand shape to another. Time is wasted when the hand is removed totally from the fingerboard as the student 'hunts' for a new chord—one that was already under the hand! Stamina is then squandered as the hand struggles to return to the fingerboard in a shape that was lost and now has to be reconstructed. A double waste of time and energy has been perpetrated when a simple, slight and quick shift would have accomplished the same goal. This could be time and energy saved thriftily for a truly complex passage where it could have been used. However, this energy has been spent elsewhere.

New guitar students invariably learn the following chords within their first month of lessons. Few teachers take the time to explain the very simple relationships between the chord shapes and the new student spends hours creating one hand shape and then learning (or relearning) the same shape to make the next chord. Hours of aggravation and struggle could be eliminated if the student had been merely told that this is all slight variants of ONE hand shape!

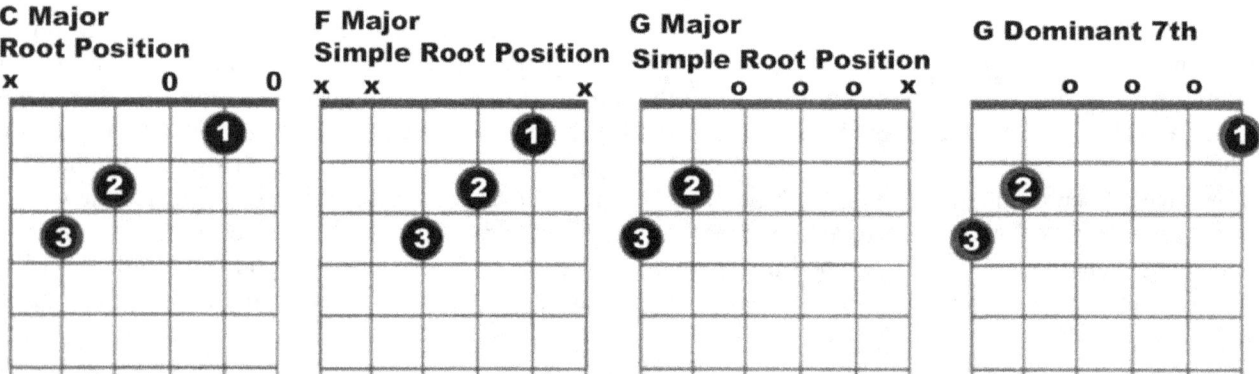

Observe that in all the block diagrams above, fingers 2 and 3 stay in the same basic form; they simply move to another pair of strings in unison, in many progressions, to adjacent strings! When moving from the C major to the F major to the G dominant 7^{th} (the standard I, IV, V_7 progression as taught in many methods) the hand need never change shape, it is only a question of what strings the fingers fret!

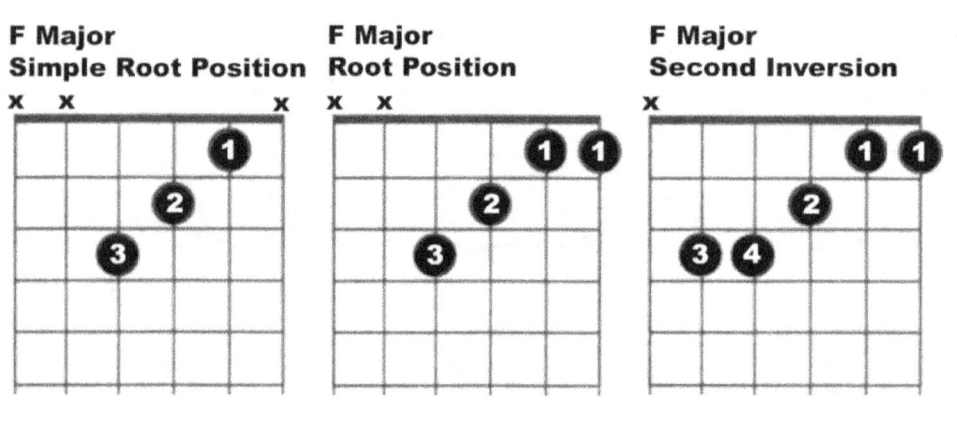

Of course, the most commonly known form of the F Major chord is *__not__* the simple form found to the far left. The middle diagram illustrates the common form of F Major.

When moving from a root position (or first

inversion if the A string is allowed to sound) to the second inversion (C in the lowest voice of the chord), the fourth finger comes into play. Please observe the fingering in the F Major second inversion diagram and keep this in mind when studying the E Major moveable barré form in the next section. A very useful and common hand position is also rarely taught as interrelated: that hand shape that generates E major and a minor – and their corresponding moveable forms (Barré chords.) The chords are taught as follows in their rudimentary form:

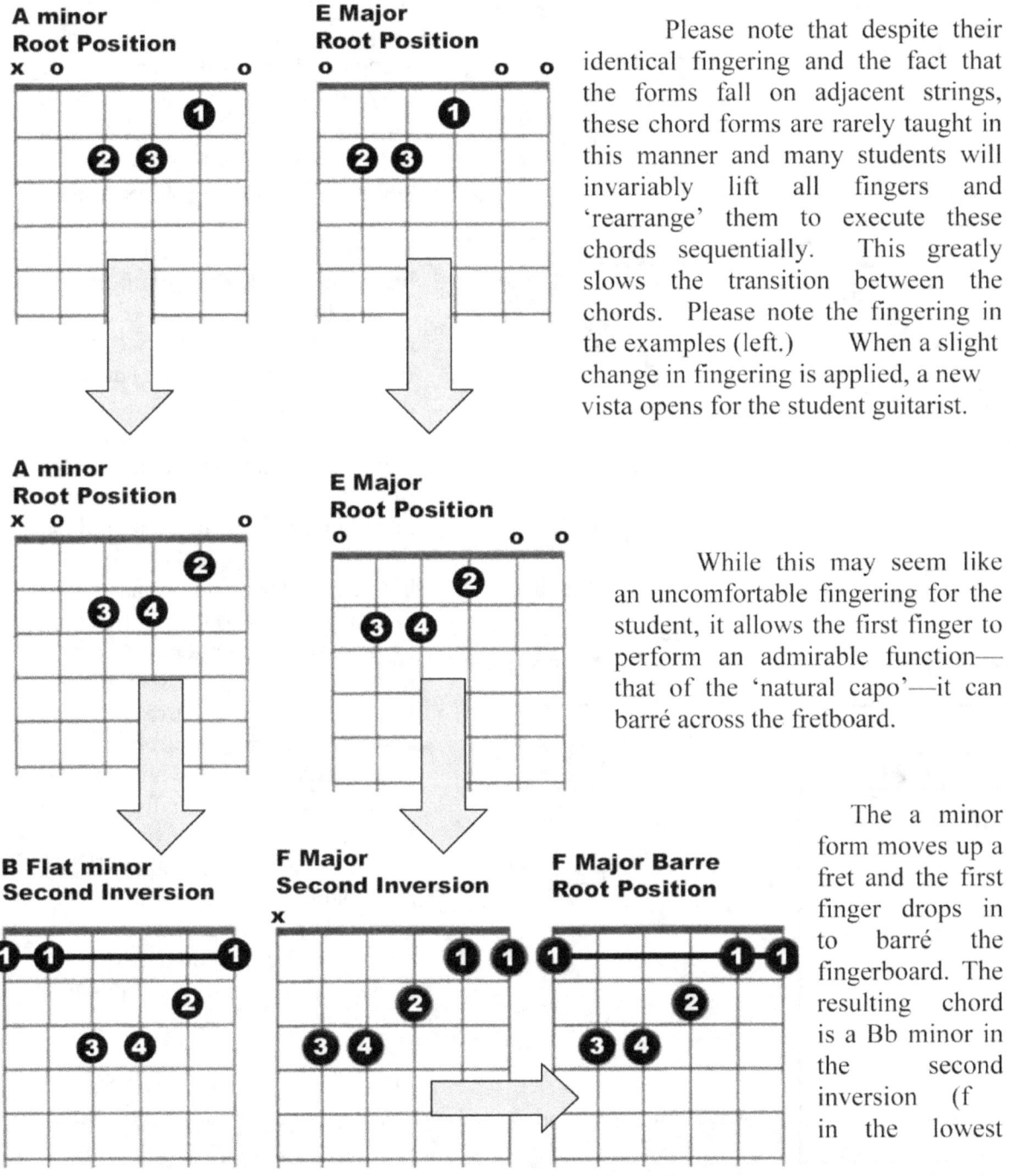

Please note that despite their identical fingering and the fact that the forms fall on adjacent strings, these chord forms are rarely taught in this manner and many students will invariably lift all fingers and 'rearrange' them to execute these chords sequentially. This greatly slows the transition between the chords. Please note the fingering in the examples (left.) When a slight change in fingering is applied, a new vista opens for the student guitarist.

While this may seem like an uncomfortable fingering for the student, it allows the first finger to perform an admirable function—that of the 'natural capo'—it can barré across the fretboard.

The a minor form moves up a fret and the first finger drops in to barré the fingerboard. The resulting chord is a Bb minor in the second inversion (f in the lowest voice of the chord.) Remember the F Major described earlier? It is now easy to see that the second inversion basis form is related to the E major root position chord. The grand barré transforms this open position chord into a 'moveable' chord form (insofar as there are no non-chord tones across the strings) that can be used to generate a root position major chord (in half step increments) along the entire length of the fingerboard.

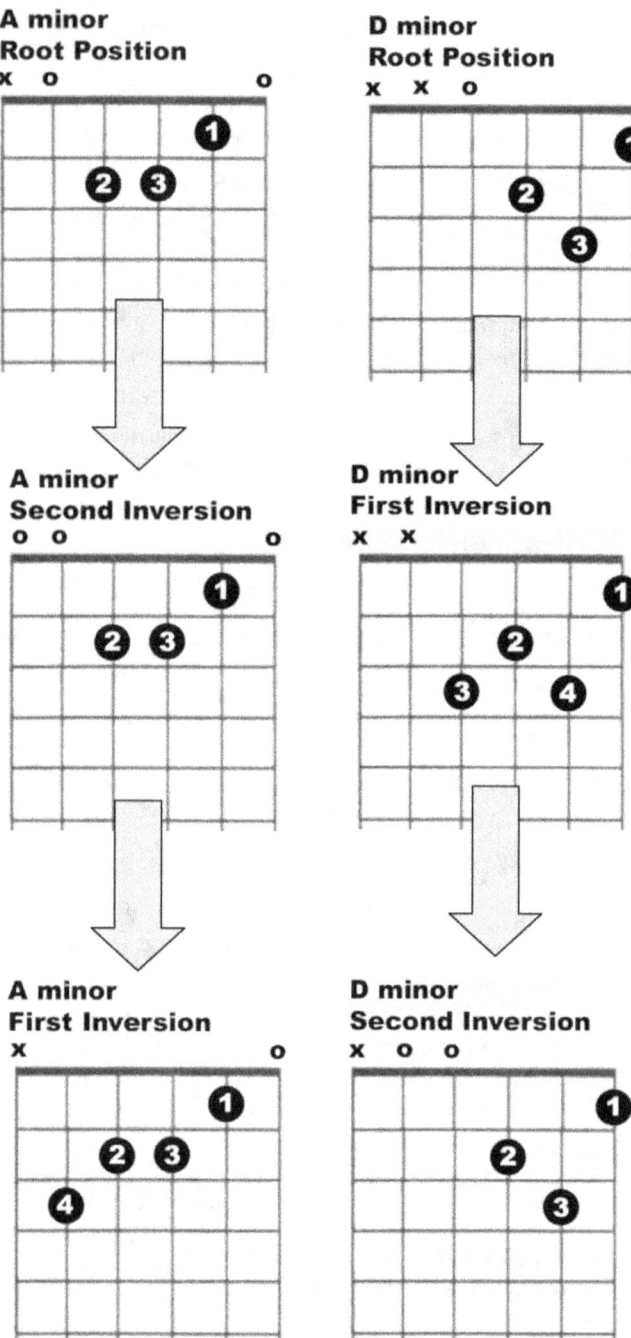

The basic d minor as taught in most methods and displayed in guitar chord encyclopedias is also *closely* related to the a minor chord shape. Fingers one and two are once again in the identical arrangement within the two chord forms; simply moving between adjacent strings. The third finger is the only difference in the pattern, moving up a half step to the third fret. Inversions of this d minor are almost as simple as those found with the a minor shape. It is in the root position in this example since the open D string is sounding.

In the example of the a minor chord (far left) we see a first inversion variant. The C at the third fret of the A string is being fretted by the fourth finger. With the example detailing the first inversion d minor chord, the third finger frets the f natural on the third fret of the D string. In both examples an additional finger had to be added to the chord shape to generate the inversion. The a minor chord will most often be found as a partial barré with the first finger taking the fretted notes indicated as 2 and 3 in the diagram with the second finger fretting the low C. The C on the first fret of the B string is eliminated and redundant.

The second inversion a minor can be executed two ways using the original root position fingering. The simplest is to merely sound the fourth through first strings which gives the fifth of the chord (E) in the lowest voice (second fret, fourth string.) Simply plucking all six strings will also give a second inversion a minor with the low E string supplying the fifth. D minor is also the root position chord shape but once again, sounding the A string along with the open D string (which would be the lowest note in the root position) yields a second inversion chord.

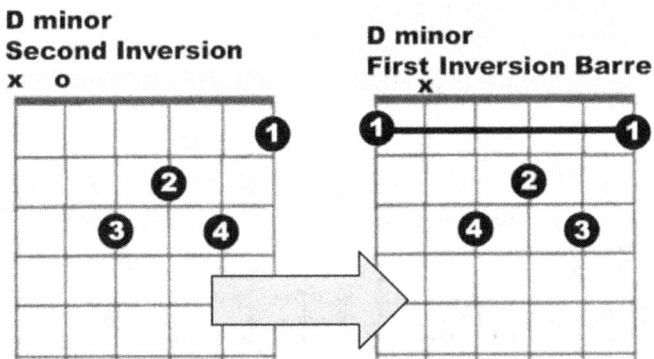

By simply repositioning the first finger in the second inversion form from a single fretted pitch to a grand barré, a first inversion moveable position form. A moveable form generates a useable chord at any fret. In other words, the d minor chord at the first fret yields a d# minor at the second fret, an e minor at the third fret, etc.

The F major root position barré chord demonstrated earlier is also a moveable form. Other so-called moveable forms can be created from the basic commonly known open position chord shapes. Please follow the evolution of the D major chord.

An expanded D major chord, either in root position or in second inversion, can yield a small number of secondary shapes; one of the most commonly utilized being the alternate version shown at left. All of the open position chord shapes can and are utilized along the fingerboard as moveable forms; the guitarist must have a solid knowledge of what pitches or parts of the triad are present.) Please note the relationship of the d minor first inversion with the d major first inversion. One can readily see the half step (one fret) difference between the f natural (third fret, third finger) with the f# (fourth fret, third finger) as well as the change in fingering to realize the same chord shape on the third and second strings (first and second fingers in the d major and second and fourth in d minor.) Also note fingering change in root position chord. (Constant chord shape.)

The A major chord shape is also closely related to the a minor shape. The easiest method of converting the a minor to the A major form is to raise the c natural to c sharp by fretting the second string second fret rather than the second string first fret. The first finger is removed and the fourth finger frets the c sharp. The second inversion form is then easily attained by simply not sounding the fifth (A) string. The first inversion requires a re-fingering of the basic chord shape. As the reader will have noted, the chord shape spans three adjacent strings

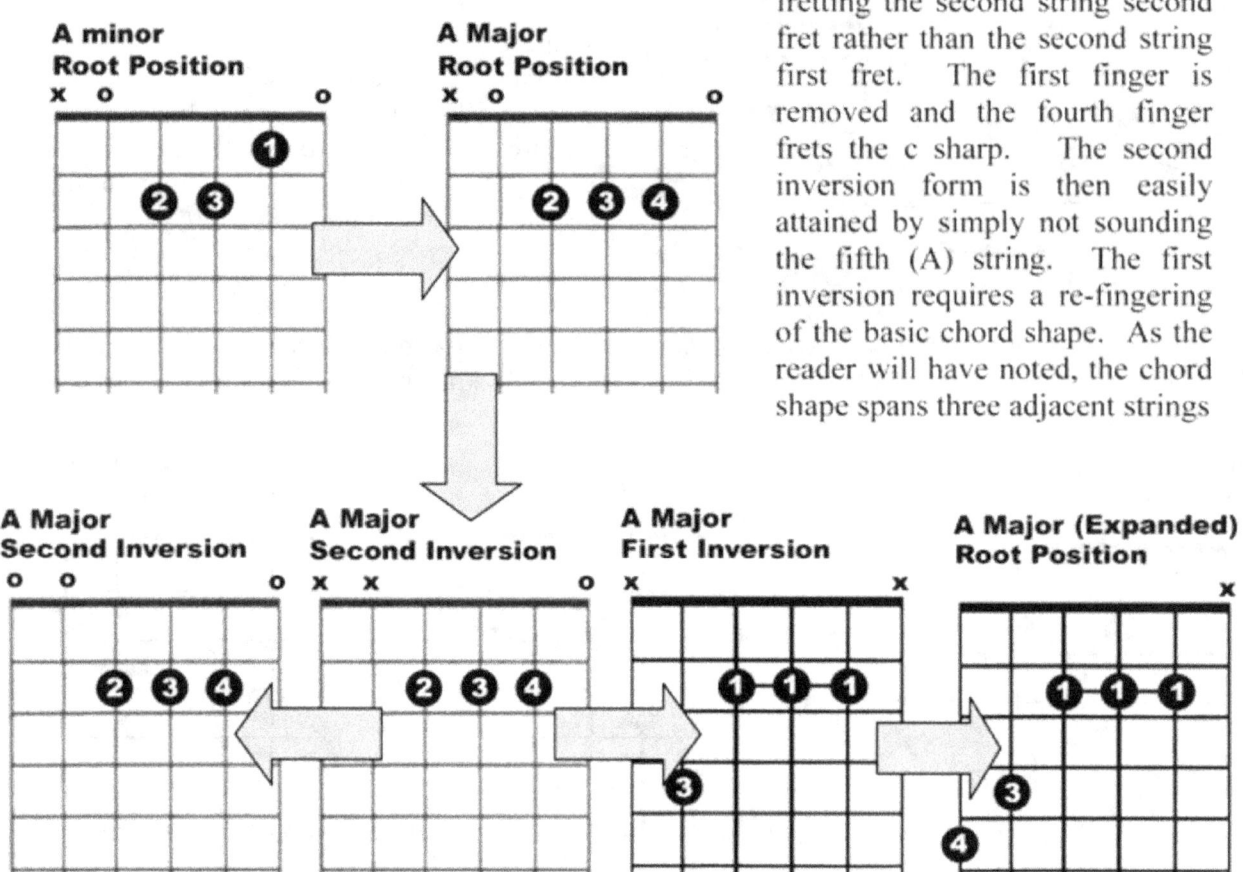

on the same fret. Hence a simple partial barré is all that is required to generate the chord. With the partial barré the third finger can be utilized to fret the c sharp on the fourth fret of the fifth string. This leads to an alternative fingering of the A major root position chord. With the partial barré fourth, third and second string at the second fret, the third finger frets the c sharp as in the first inversion variant. The fourth finger then frets the A at the fifth fret of the sixth string rendering a root position chord shape.

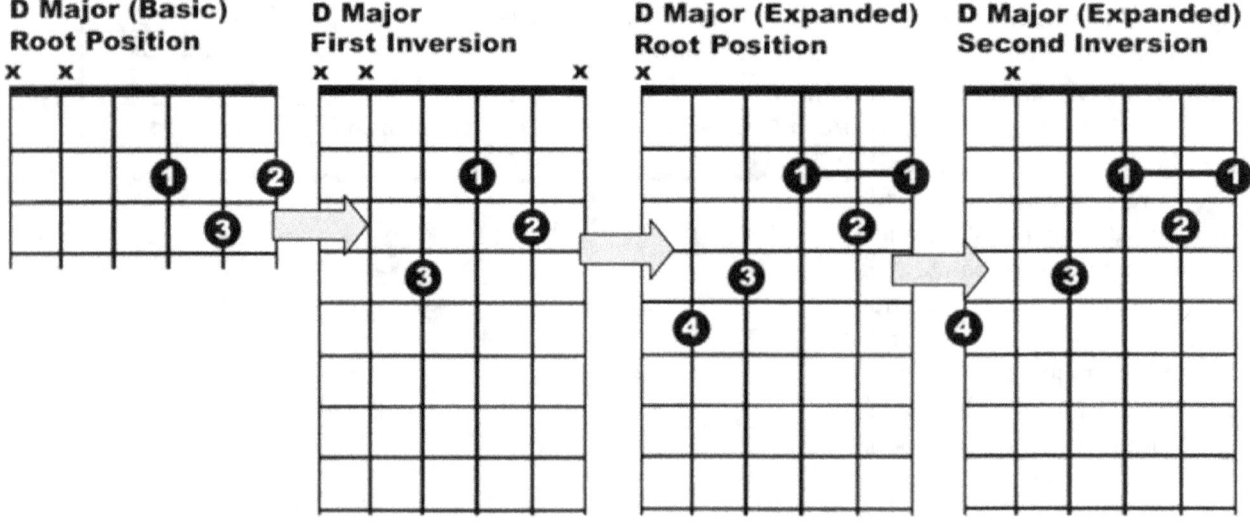

The Art of Interpretive Fingering

Fingering to Alter Timbre Through String Voicing

Six strings *plus* notes that are written on one specific line or space but can be played in two or three different places on the neck; and on different strings often *equals* confusion to the new student. Segovia said the guitar was like an orchestra looked at through the wrong end of a telescope. He also said **"The guitar is a small orchestra. It is polyphonic. Every string is a different color, a different voice."** This concept is incomprehensible to those who have either never played the guitar or have played it very little. Critical listening reveals the reason. Please observe the following piece, the first in a series of five pieces.

Five Anonymous Lute Pieces

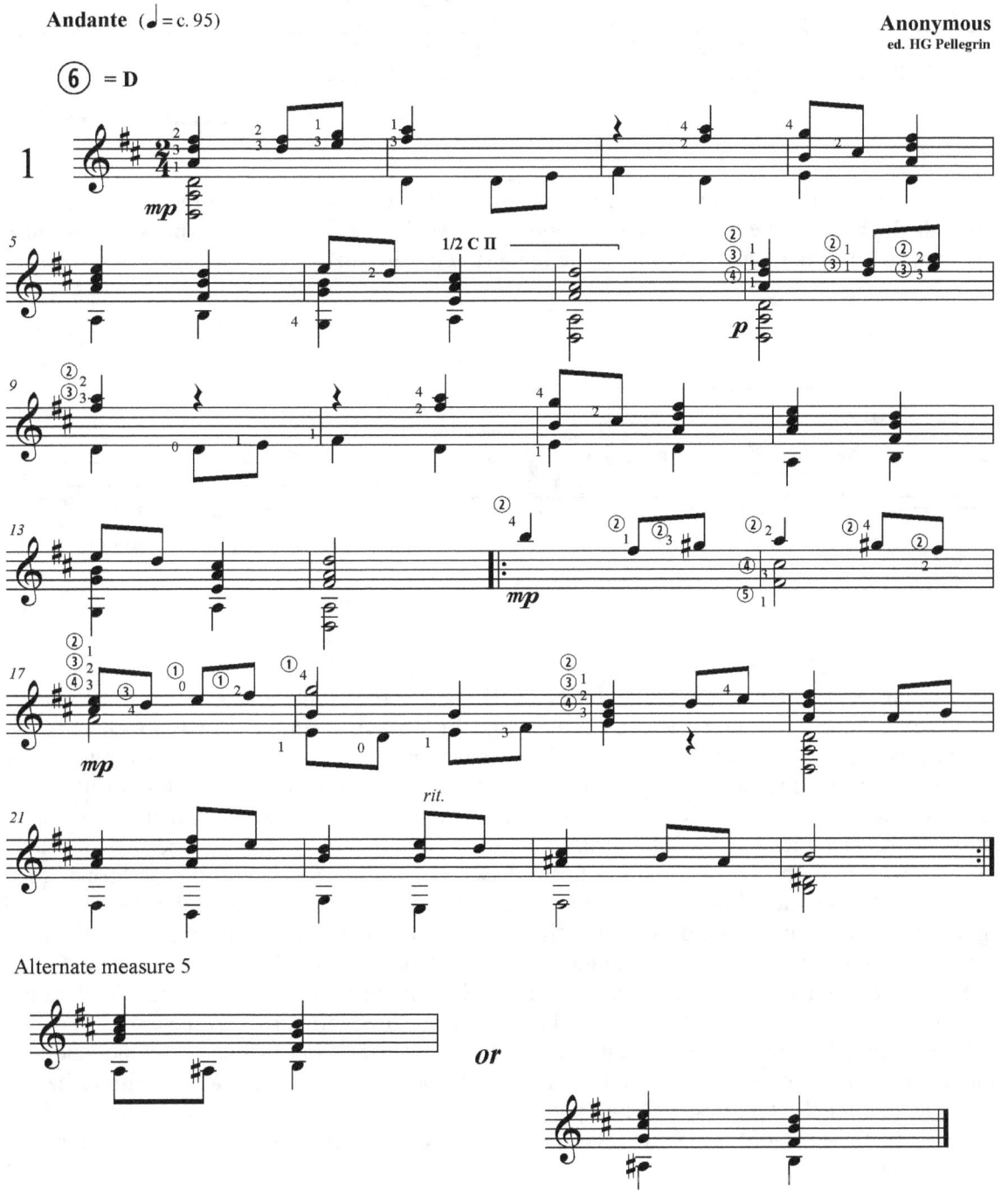

Alternate measure 5

One should think of the guitar as an ensemble of six single-stringed instruments. Each instrument produces a different type of sound: the soprano clarity of the first string; the warm cello-like lyricism of the fourth string; the deep, dark and luxurious bass of the sixth string. Is this overly romantic? Definitely not! Certainly a melody can be played in first position on the treble strings, but if it is something other than a happy, snappy bright little melody, it will sound wrong – like the flute trying to be a viola. This is not necessarily evil, just possibly not what the performer may require.

This Lute Piece has been fingered carefully to produce an effect. The sonorous melody of the B section of this piece could (and probably was) originally played in open position such as this:

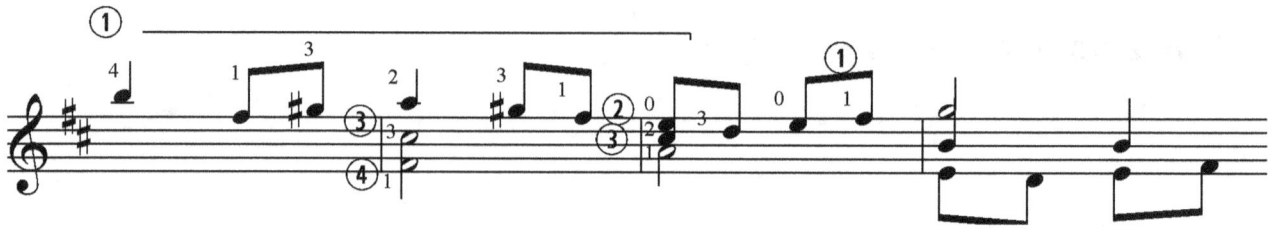

It sounds decent enough, but by moving the melody to the second string (and the attending harmonies to adjacent strings) the melody can be rendered with a more plaintive feel. Play the sample phrase above utilizing the indicated fingering, and then play the following. Note the difference in 'feel'.

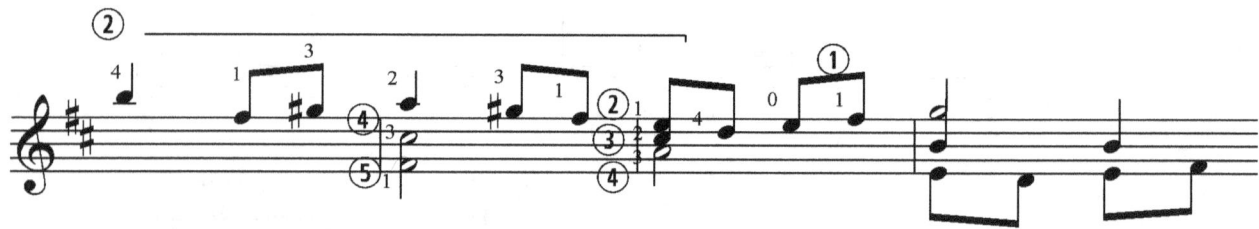

In other instances, a difference in the fingering of one note – for example at a decisive point in a phrase—can produce a vastly enhanced emotional effect. In the Miguel Llobet fingering of Carcassi's Opus 60 Number 3, which is still arguably the finest edition of this work, simply changing an open string to a fretted pitch heightens the emotion of a phrase by allowing the performer to 'sweeten;' the note through both the less brittle sound of the second string as well as the now-available ability to use a slight amount of vibrato. Included here is the beginning of the B section of the piece leading to the A prime section. The crucial measure has been duplicated with the slight change in fingering. The original edition utilized two open strings to allow the performer to transition smoothly from the ninth fret back down to "open" position. In the amended fingering, the performer utilized the open b string to shift from the ninth fret down to the fifth fret—performing the 'e' with the fourth finger of the left hand. The left hand is now in close proximity to the second fret from whence the piece continues. Other editions do not include this fretted pitch; rather the open string is used as in the Llobet edition. Many modern editions do include a *ritardando* at this measure (not Llobet's) and one even has three fermatas over the d, b, and e! As with all fingering changes intended to aid in the musical and emotional interpretation of the piece, the student of guitar fingering should play both fingering versions and determine whether one or the other allows him or her to perform the phrase with the emotional intent desired. Interpretation is a rather personal decision and it should be stressed with great emphasis that one person's opinion is, ***within reasonable constraints***, just as valid as another's.

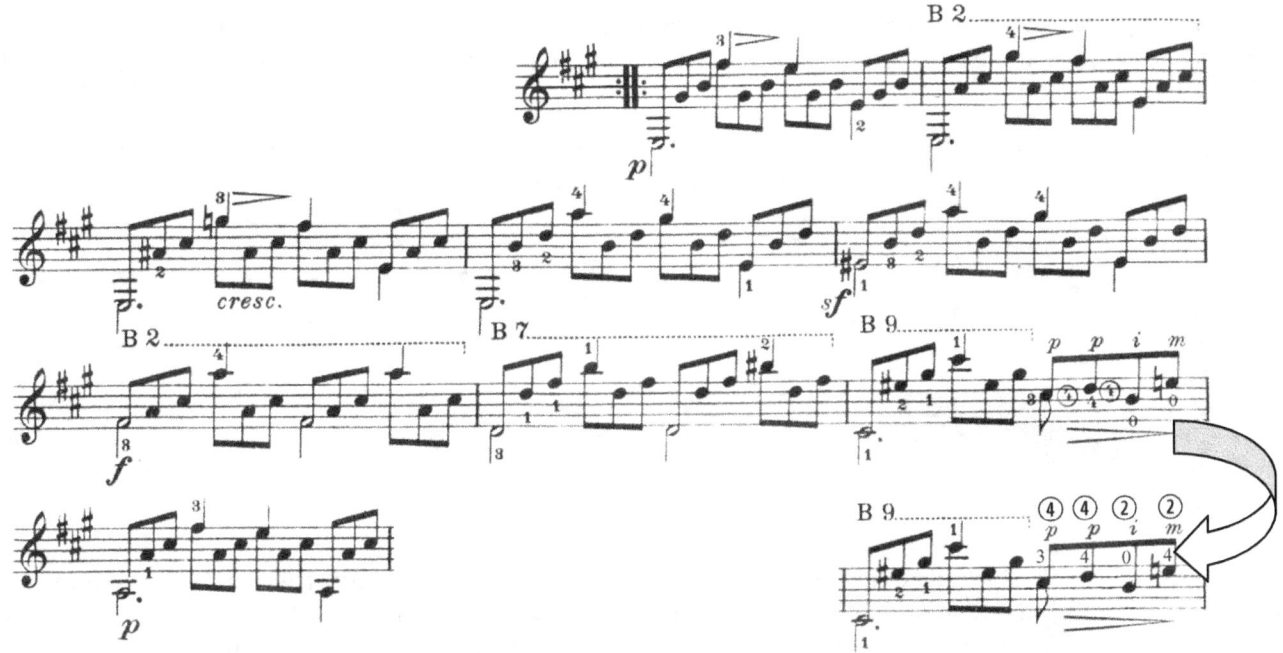

Fingering to Smooth the Flow of an Arpeggio

The first two measures of Carulli's Opus 114 Number 9 are fingered as illustrated in at least one popular edition as indicated in the top line of the following musical example:

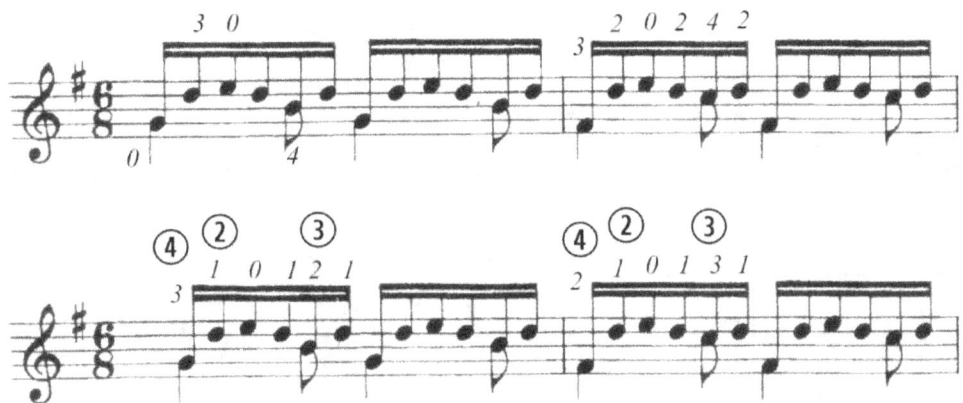

The fourth finger must fret the note 'b' and then release to allow the open g string to be sounded. This wagging finger is an unnecessary disruption to the flow of the arpeggio. The repeated fretting and releasing of a note to facilitate the sounding of an open string wastes time, energy and in some instances can lead to fretting inaccuracies. At best this type of fingering impedes any possibility of producing a legato effect such as allowing the open string (as well as the note being fretted) to ring *slightly* past its duration. By simply refingering as shown in the second line, left hand motion flows better and is more progressive in nature.

Fingering to Smooth Left Hand Transitions

Fingering that might otherwise be perfectly acceptable for the execution of a particular hand shape may be rendered inadequate by the hand shape that must next be executed. Even the transitions between relatively simple hand shapes can lead to difficulty as preparation is essential to a smooth transition. Once again we turn to Carulli's

Opus 114 for a prime example of how what appears to be an adequate fingering can be adjusted to facilitate the transition to come. The top two measures indicate the recommended fingering in still another edition of Carulli's preludes.

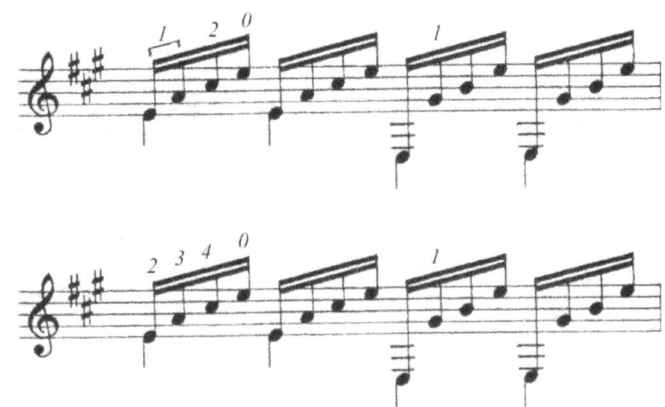

The editor has indicated that the first finger should barré the fourth and third strings at the second fret while the second finger frets the second string at the second fret producing as A major chord in second inversion. This *mini-barré* forces the first finger knuckle into an awkward reverse bend. It also ensures that the first finger will have to release and reposition to execute the G# on the first fret of the third string in the following measure. The measure prior to the example presents no need for the fingering indicted in the first measure of the sample. Therefore I believe it is a more productive use of the left hand to finger the measure as indicated in the first measure of the second line of the example. By eliminating the barré and using three fingers that will *not* be

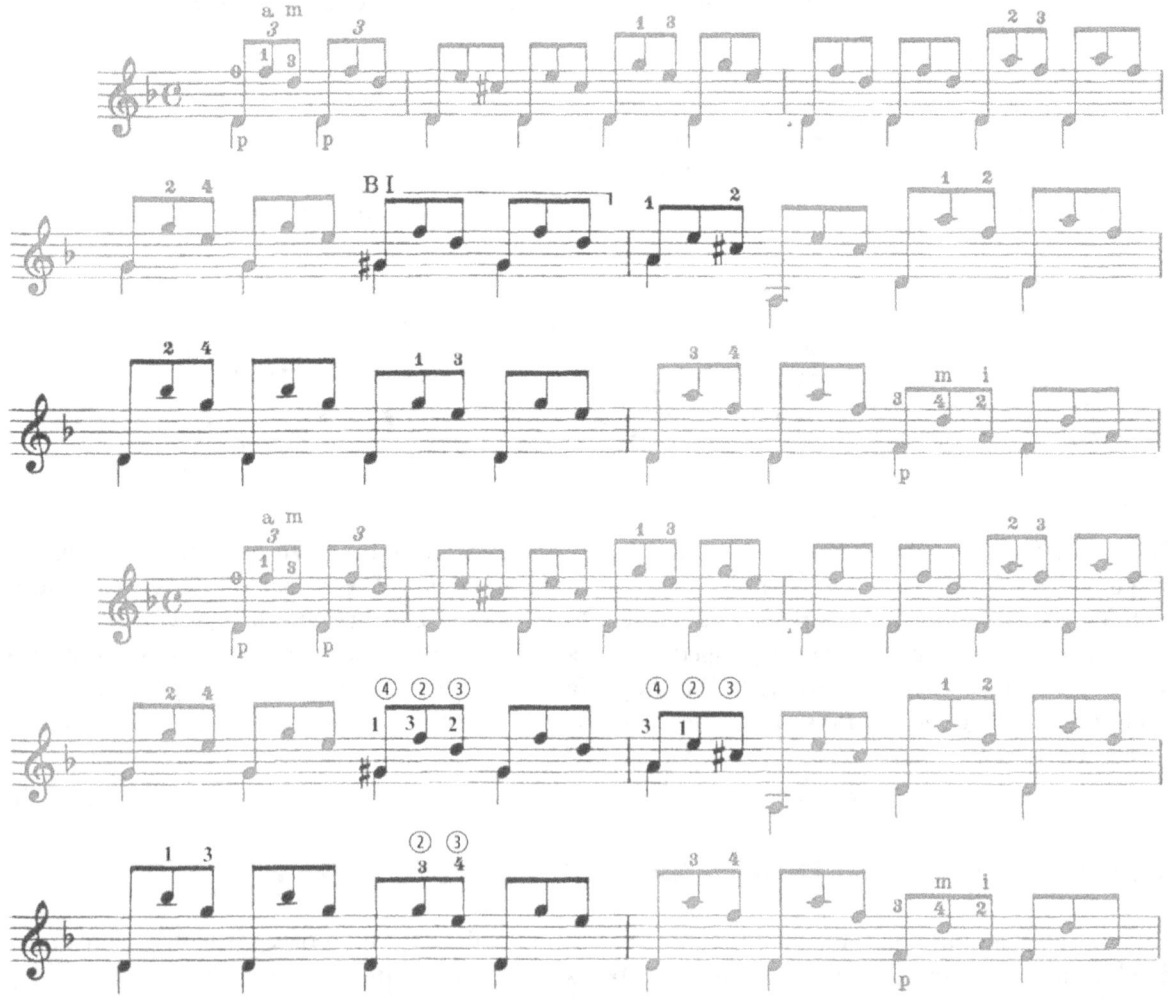

required in the following measure, the first finger is already 'hovering' over the note it will be required to fret in the following measure. When the time comes to transition between the hand shapes at the bar line, the three fingers in use can be removed simultaneously with the first finger moving in to fret the G#.

Fingering for Timbre and to Ease Left Hand Transition Memorization

Often editors and transcribers will simplify fingering to make the piece more accessible to the new student. Indeed, fingerings are often created to facilitate the performance of the seasoned professional! In most cases the performer should weigh out the benefits and deficits of edition fingering. Nothing is engraved in stone, even if the edition was created by a much loved and highly respected performer, transcriber or editor. What is deemed correct by one person may not be even playable for another. What may be deemed a necessary simplification for a student may leave the seasoned player unable to shape or color a phrase in the manner that seems fitting to him or her.

A popular edition of Sor's Opus 35 Number 17 contains a passage that is a case in point. The original editor's intent is not known nor is it possible to ascertain beyond all doubt as death separates us from him. The edition fingering does pose a few difficulties from various standpoints: ease of execution, tonal coloration and even ease of memorization! Presented below is the passage as it stands in the aforementioned edition:

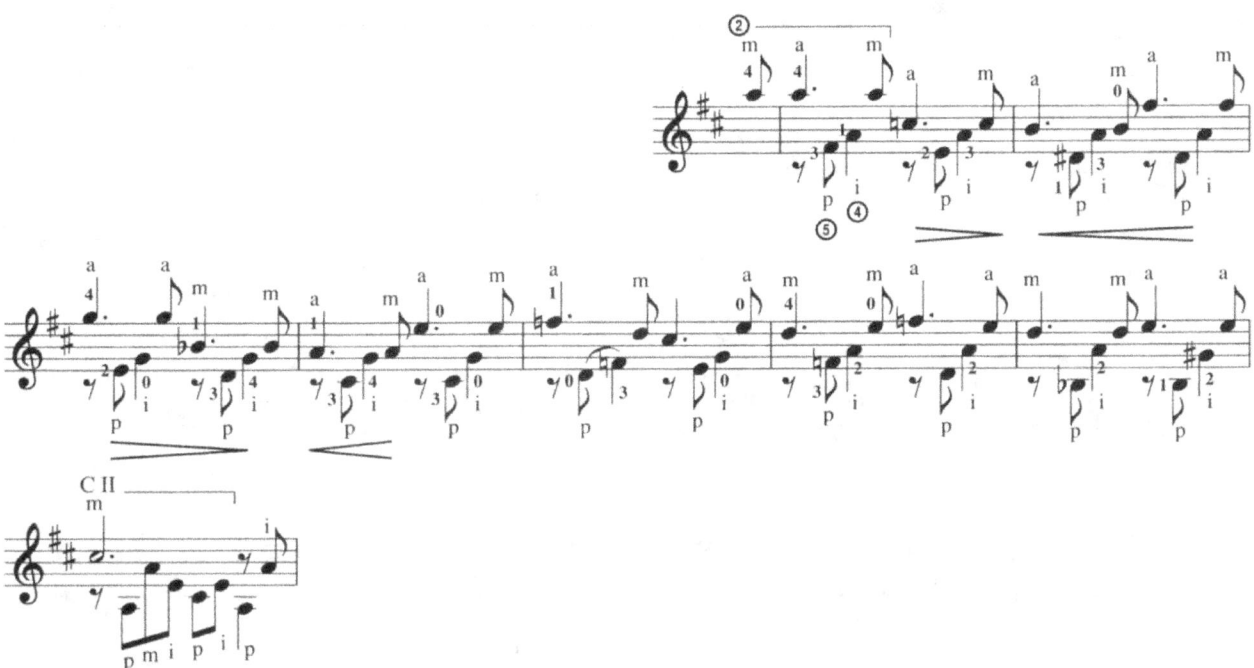

Note that the editor brings the melody (that could easily be played on the first string at the fifth fret when we observe what follows) up to the tenth fret on the second string. This allows the performer to 'sweeten' the note more than if it had been executed at the fifth fret but the fingering then appears to nose-dive down to the first fret for the c natural on the second string. While this allows the rest of the passage to be executed in the student-friendly open position, the fingering is cumbersome in two respects. First, there is a large jump up to the tenth fret with a corresponding jump back to the first fret. The fingering then becomes a constantly shifting array of non-repeating hand shapes. There is no easily recognizable pattern to ease memorization and the timbre shifts from the warmth of fretted strings to the comparative brittle harshness of open treble strings. This is acceptable to a student's ears, but it leaves most seasoned players wanting something more. Here is my edition of this piece. I do not claim it is the only choice of fingering producing the finest performance results; it does produce a cohesive timber and a repeating series of hand shapes that lead from the tenth fret back down to the open position without any large jumps or awkward fingerings.

Etude Opus 35 No. 17

Fernando Sor
(1778-1839)
edited by H.G. Pellegrin

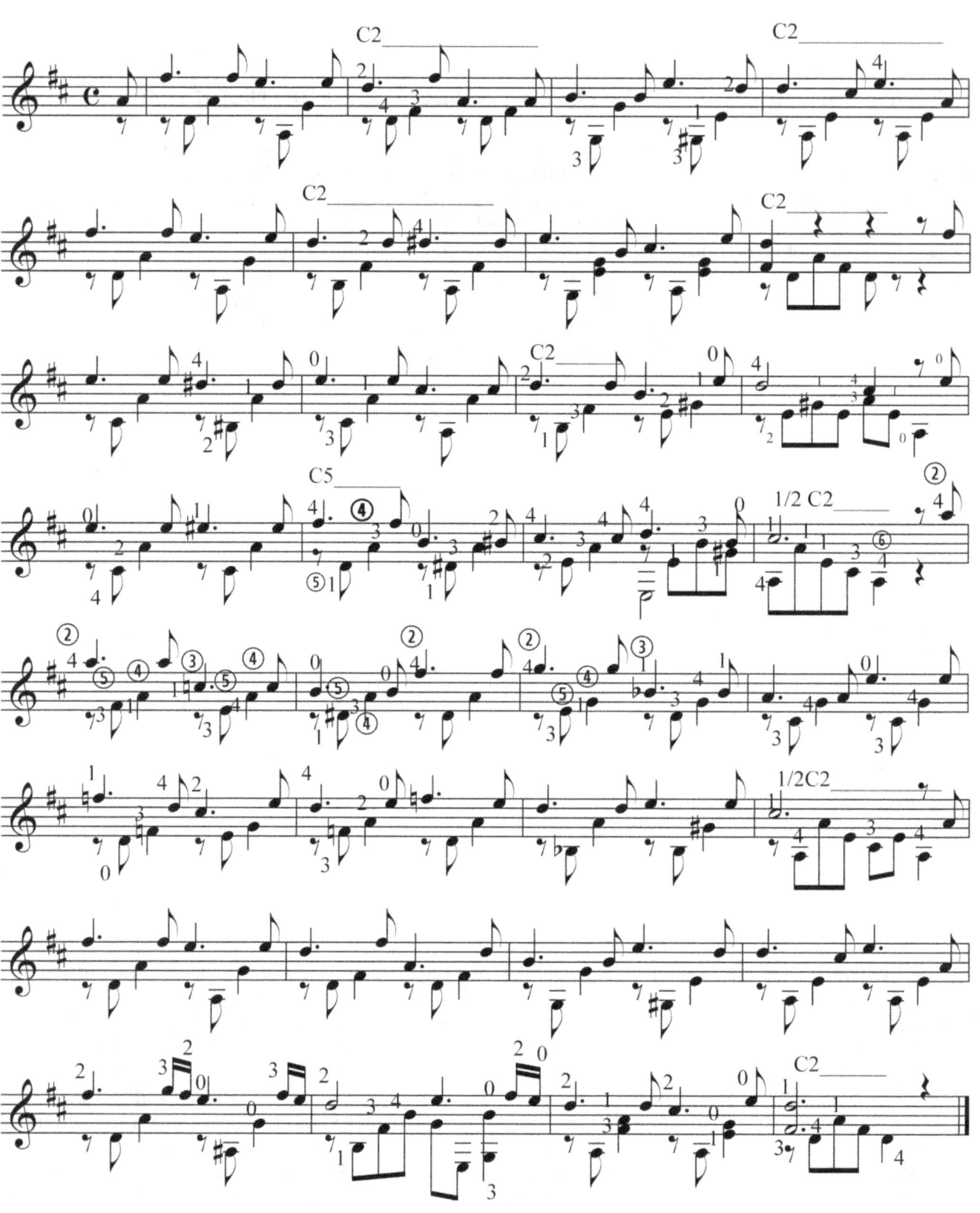

Here is the passage in comparison between the old edition and my suggested fingering:

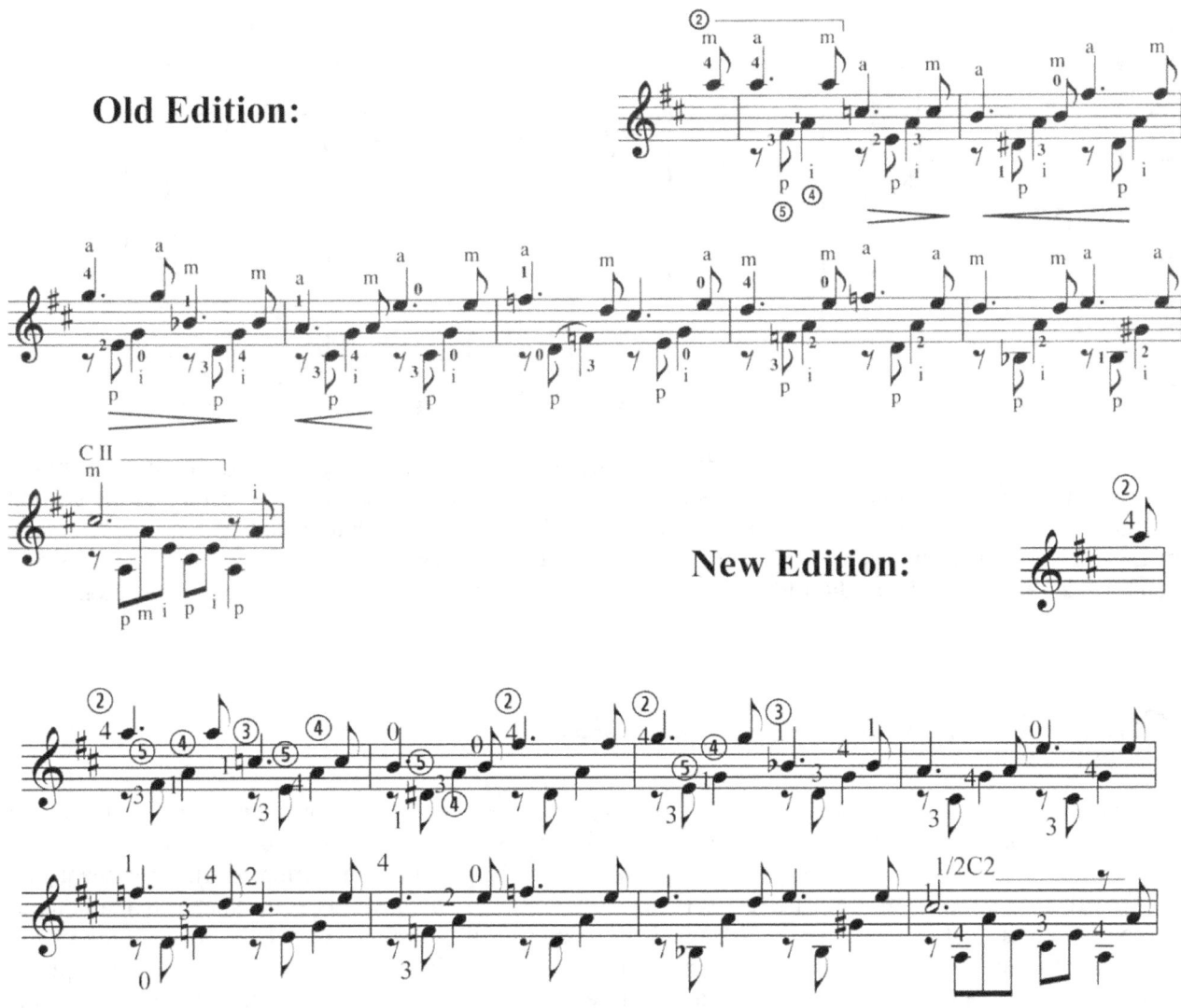

The hand shapes break down into four distinct chord shapes that allow the performer to maintain similar timbre through the passage and ease memorization through the cyclical nature of the execution of these hand shapes. The following diagrams illustrate this point:

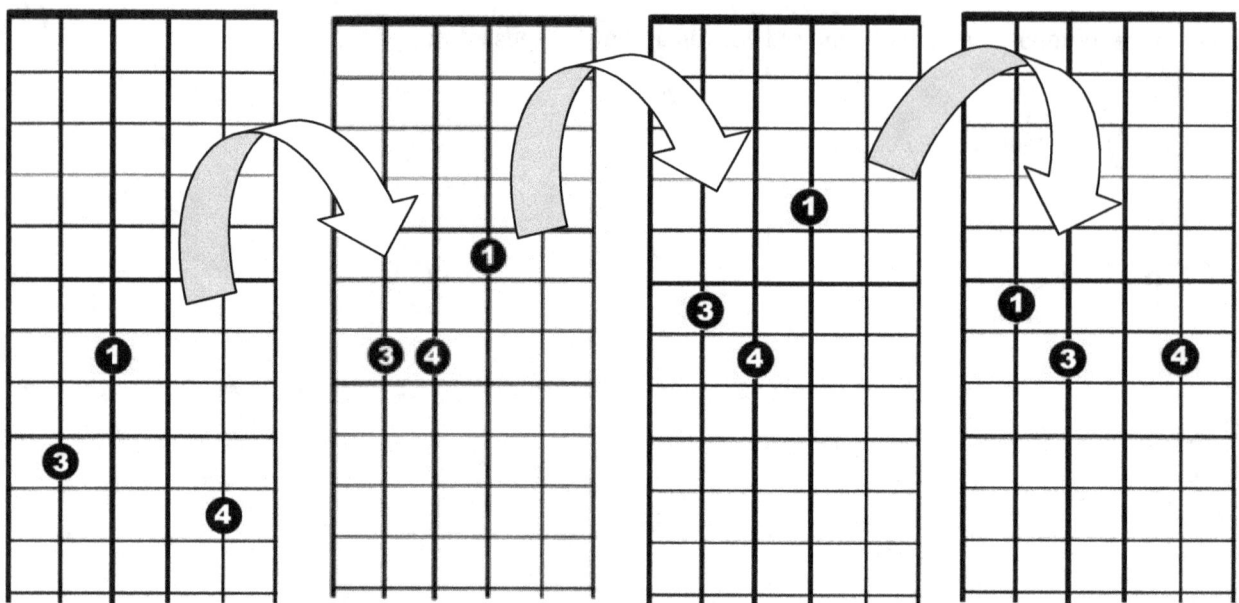

This pattern the repeats with the same chord forms starting with the fourth finger in diagram one occupying the second string/eighth fret position. The pattern is completed with first diagramed chord executed at the second string/sixth fret. One caveat: the performer must maintain good left hand finger arch to cleanly perform the passage as many pitches are played 'behind' the fretted pitches. Flattened fingers will mute strings. I believe it was this phenomenon that caused the previous editor to avoid the repetitive pattern and jump back to the open position.

When *Could* a Large Jump be a Good Thing?

There are times when what might seem to be a logical fingering—one that allows the performer to stay in position and, on paper, has a certain flow—that is not a good choice. Many times this will be a consideration made by a desire to create a certain flavor by the timbre change attained by the position (and string) shift. Yet, the astute student will find that what seems to be a perfectly logical fingering *for them* yields somewhat less than stellar results. The following musical example is culled from Ferdinando Carulli's Prelude 11 (Opus 114). Many of my students found the transition from measure five to measure six to be a bit awkward—it seemed that the prime difficulty was allowing the final 'b' of the measure to ring for even its brief sixteenth note value. I have played this prelude either as a study aid as a young guitarist and later with my students for the better part of thirty six years, so that transition's difficulties are buried, for me, in the forgetful sands of time. I never liked the awkward use of the third finger in measure seven. It never was a real issue, but I always felt it was clumsier than it should be

I love my students. It would seem I have learned as much from them as I did from any instructor I have had the pleasure with which to have studied. One evening a student who had had interminable difficulty with that measure five to six transition played it flawlessly. I had my eyes closed listening to his tone and as he passed the four measures in this example I realized all the prior hiccups were gone! He smiled at my astonishment and told me he had refingered the section. I tell all my students that edition fingering is nothing more than another's opinion. If they have a different concept of what the tonality and timbre should be, or if they can find an alternate fingering that works as well or better allowing all notes to ring for their correct rhythmic values, etc., **_and_** they can give me a reasoned explanation for that change, well, they are more than entitled to make these changes. With all these thoughts in mind, I had the student repeat the prelude and I watched the left hand throughout. The following is the fingering used:

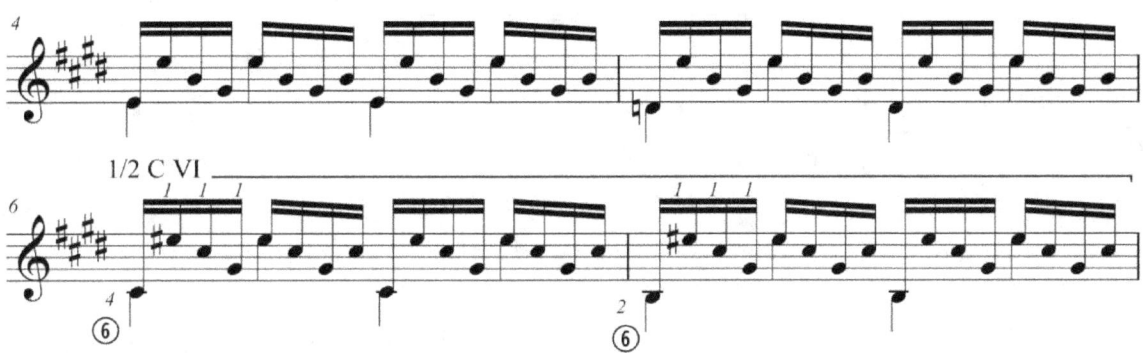

At first I was rather shocked at the large position shift that I had seen—but had not heard. I resisted the urge to say 'No, no, no!' because I have found in life that the more I am averse to accept something I am at first, the more I usually embrace it in the future. So, I tried it myself. By leading the transition with my fourth finger (aiming for the c# on the ninth fret of the sixth string and dropping the barré immediately thereafter) the transition was not as awkward as it first appeared. An unexpected bonus was that the new fingering eliminated my clumsy friend, the 'b' on the fifth string played with the third finger in measure seven of the first example. Now it was a simple walkdown to the second finger one fret north of the half barré. The measure immediately following the example is a half barré on the second fret—a transition very easy to accomplish even from the lofty heights of measure seven.

Fingering To Facilitate Left Hand Positioning on the Fretboard

The guitar poses interesting fingering challenges as a note on the staff can be played in numerous locations—up to four in some instances. Aside from the obvious deciding factor—what notes need to be played simultaneously—there is another consideration to be made. Where will the line be going? Does the phrase progress from the lower register to the upper? Will the execution of the phrase be hampered if fingered 'up on the box'—above the twelfth fret?

The following example demonstrated two (of a number) of ways to finger a g major scale. In each case a correct three octave g scale results.

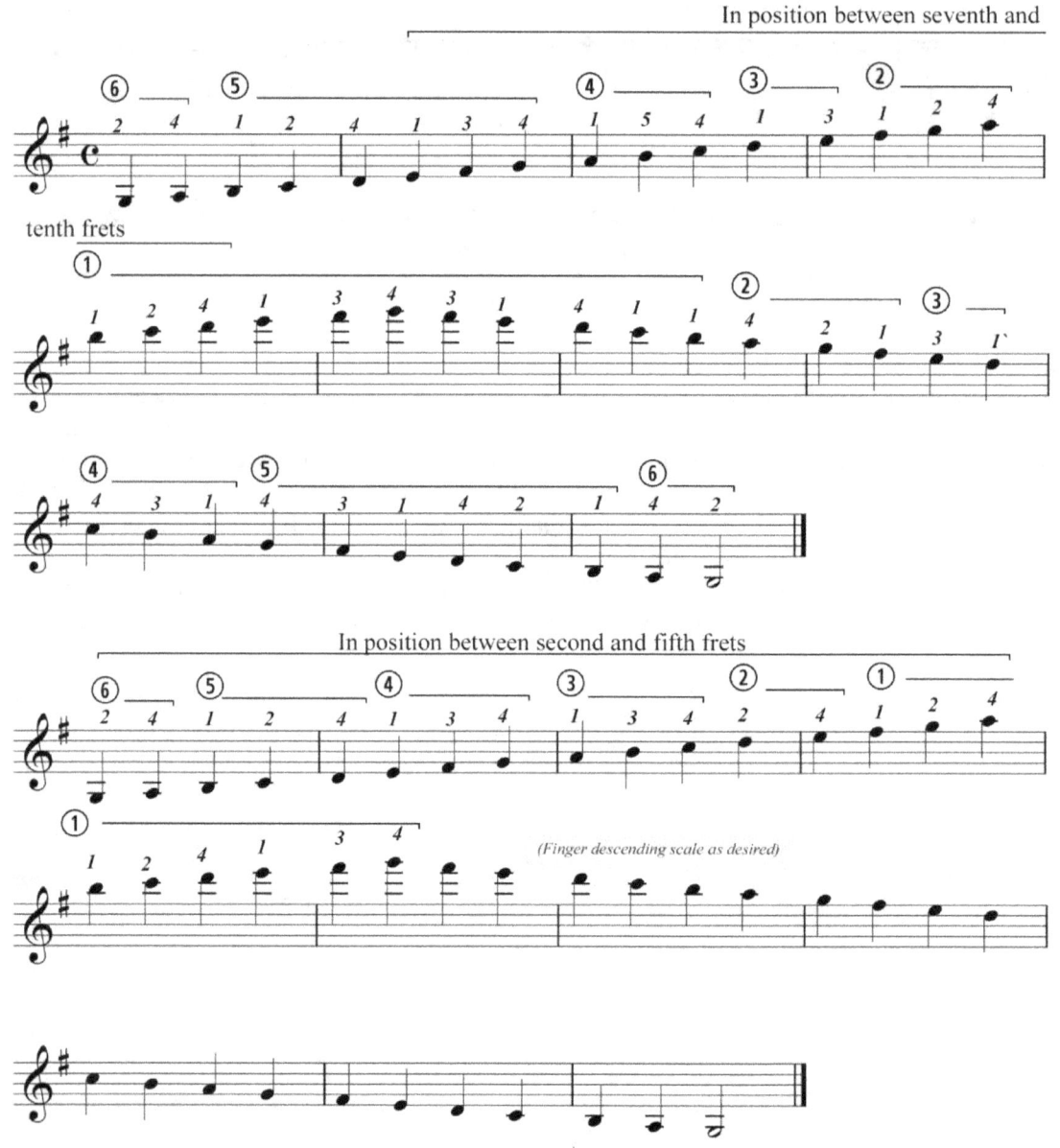

Using this scale as a pattern, which would the performer find easier to play if it were transposed to the key of B flat (moved up three frets?) The first fingered sample, in the key of G, is situated mostly between the seventh and tenth frets. If moved up three frets to execute in B flat, the position would be between the tenth and thirteenth frets—up on the box. This might not be the most comfortable or sonorous place to perform. Example two is fingered extensively between the second and fifth frets and uses the first string to climb the last octave to the fifteenth fret. This scale would be much more comfortable for the performer to execute three frets higher as a straight run up the first string is much easier. See example below in B flat. The first sample would place the left

hand mostly between the tenth and thirteenth frets—uncomfortable turf on the fifth and fourth strings! The second scale sample keeps the left hand between the fifth and eighth frets—a comfortable environment.

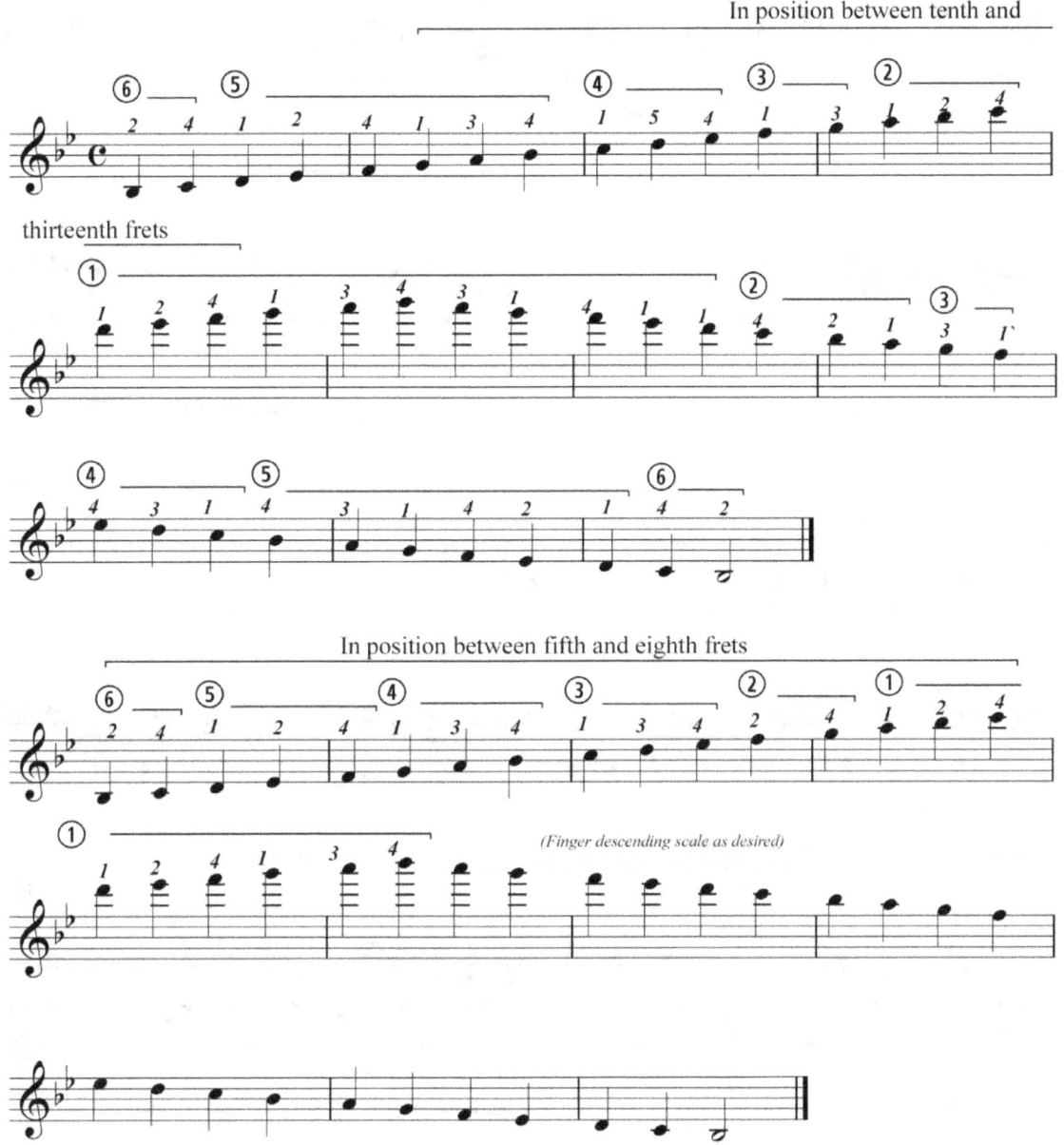

When fingering single note phrases, the transcriber/editor/performer should keep this in mind. Tempo is a factor as well. Often a brisk tempo renders questions of timbre superfluous. A presto scale leaves little tonal impression on the listener—unless performed exceedingly badly. Taking good technical performance as a given, a phrase performed rapidly on the first string should not be any less pleasing to the ear than if it were performed across two or three strings. Largo and legato phrases may be another story altogether.

Fingering to Maintain Hand Shape

In some instances what appears to be a good fingering choice can be difficult in execution. In this example from Tárrega's famous tremolo study **Recuerdos de la Alhambra** we find the following passage. Please note the fingering in the second measure quoted in the extract. This fingering is ideal on paper, remaining almost perfectly 'in position' for each position shift with the first finger fretting the C on the third fret of the fifth string, the third

finger fretting the E on the fifth fret of the second string and the second finger dodging in to play the C on the fifth fret of the third string.

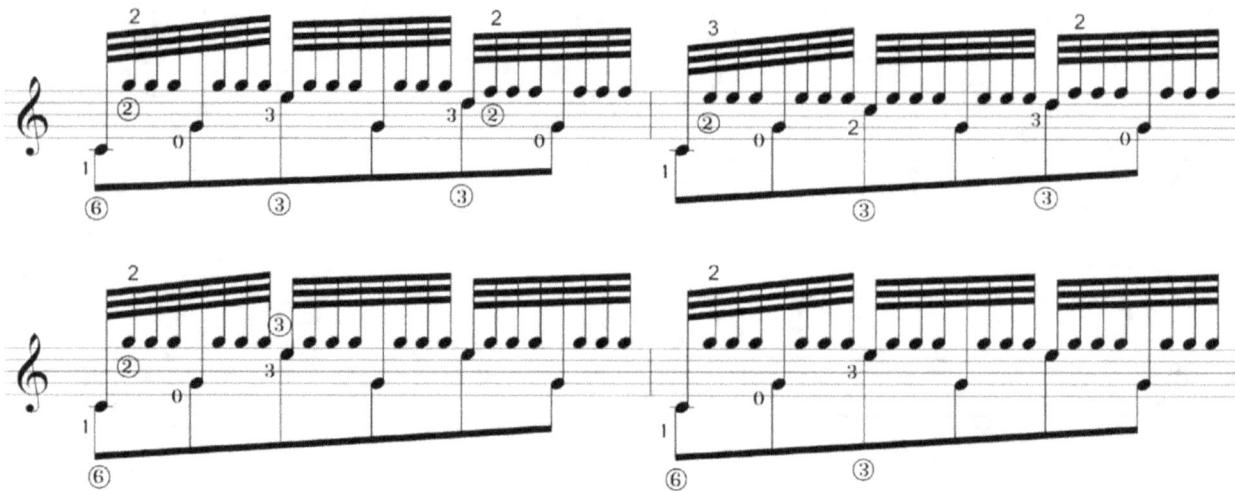

What might be considered a better fingering for this second measure might seem slightly unorthodox: The first finger once again fretting the C on the third fret of the fifth string, however now it is indicated that the fourth finger frets the E on the fifth fret of the second string. This fingering places the first and fourth finger only two frets apart—not exactly 'in position', but the third finger is now in perfect position to play the C on the fifth fret of the third string.

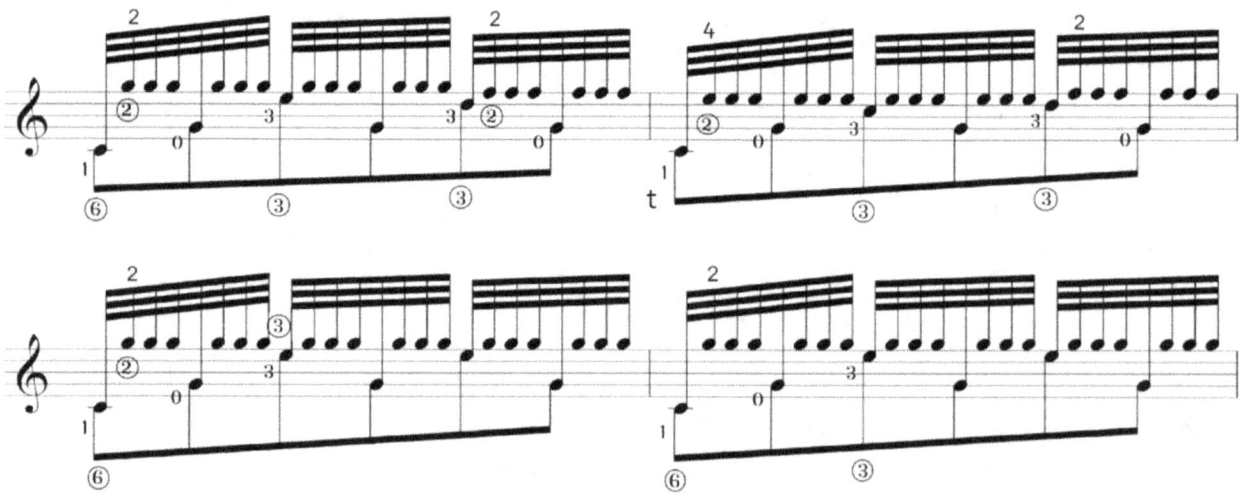

Still, as comfortable to play as this might be for many, it is no easier when executed from the previous measure into the following measure and the goal is to render an easier passage! In the final version of this extract we see the fingering that a majority of guitarists find an 'easier' fingering. Once again, the first finger frets the C on the third fret of the fifth string, but the second finger plays the E on the fifth fret of the second string with the . This is an uncomfortable stretch between the first and second finger, but it allows the third finger to play the C on the fifth fret of the third string AND maintains the same pattern of fingers used in the proceeding measure and the two measures transitioned following it. By maintaining the same physical hand shape through the passage, there is less hand motion and rearranging of the fingers making the passage easier to play *overall* and certainly easier to memorize and remember.

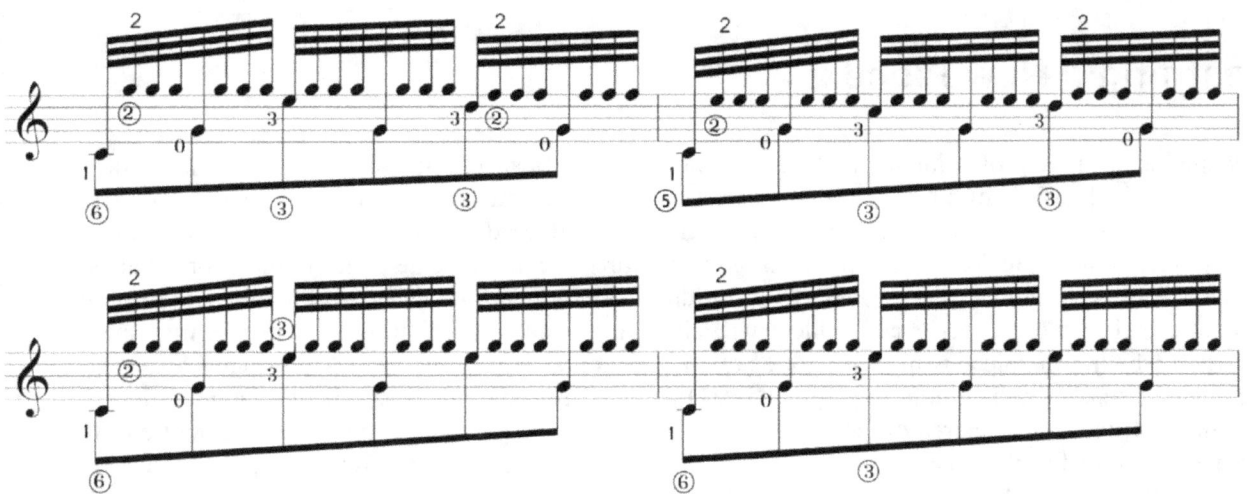

Learning a New Piece

Students as well as professionals all face a common event on a regular basis—the inevitable new piece. This is the piece of music that the guitarist has never played and possibly may never have even heard beforehand. There it sits, a white sheet of foolscap covered by lots of dots; that is what most players see. What they don't see is the harmonic structure or familiar scale patterns and chord shapes. New students will begin to make sound (note: I didn't say *play*) without even checking the key or time signatures! The more experienced student will check this data—and if he is truly astute, may even ascertain whether the piece is in the major or relative minor variant of the key. My students also scan the music to make a mental note of pitch range. (Does the piece cover the instrument's range or does it contain itself to a specific area of the fingerboard?) They also analyze how the piece is structured. Is the piece an A/B form? A/B/A? Are there any modulations or mutations? Where is the melody? Is it carried upon the higher pitched strings or does it run on a bass string – such as the melodic line in the Villa Lobos Prelude Number One? Does it hug the first string – as it does in the theme of the Sor Magic Flute Variations? My best students look at the music longer than the rest – they find similar chord patterns, scales, etc. These students spend the most time just looking at the music but also produce the best initial read-throughs! Preparation is everything. So there are many avenues one must explore as one approaches that new piece of music as it stares back from the music stand.

I have been working with two of my students using the Sor Etudes as compiled by Andrés Segovia. They are both working on Etude Five (which is Opus 35 Number 22.) This piece is remarkable on a number of levels. First it has a depth of emotional content that belies its humble 'Etude' aspirations—it is a lovely piece. Second, the left hand remains fairly static throughout the piece. If you've played the piece, you will remember that the basic harmonic structure hovers between the tonic and dominant harmonies for most of the piece with a brief sojourn into the subdominant tonality (including one of my favorite preparations of a C major chord in first inversion in the repertoire) and then Sor throws those last two lines at the student…always the student's least favorite part of the piece.
Here is the A section of Sor's Etude Opus 35, Number 22.

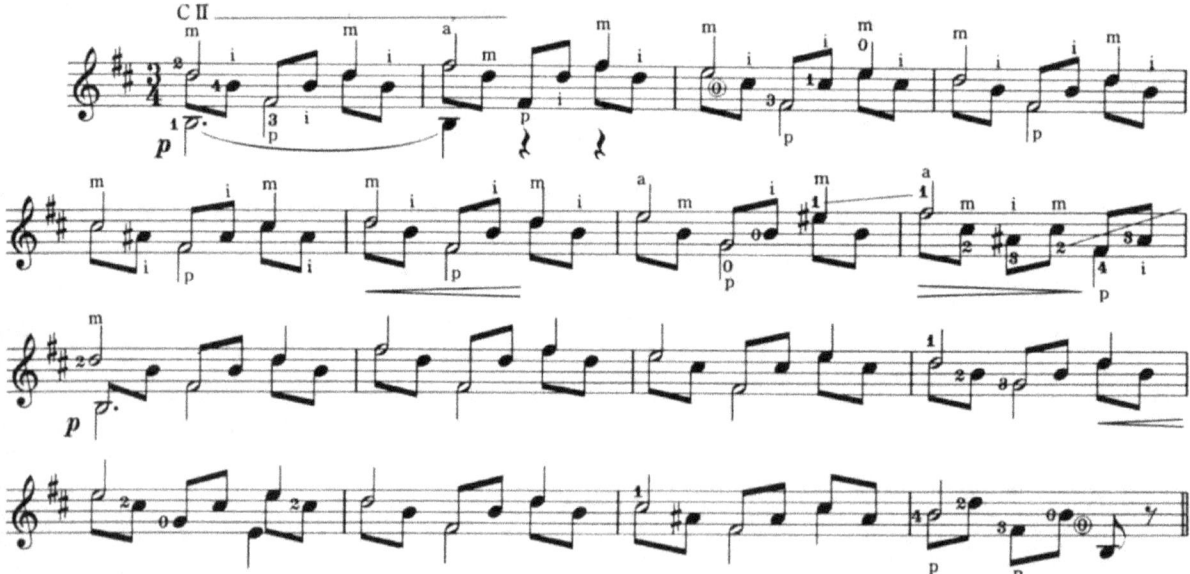

What would one of my students say about this selection? First they would tell you it is a triple meter piece (3/4 time) and it is in the key of B minor. Why B minor? Why not D major? The key would be correctly determined because they would look at the first and last measures and note the B minor chord outlined therein. This would be coupled with the A#'s in the piece (the harmonic minor leading tone that produces an F# dominant (or dominant7) chord. Then the student would look at the piece and find the melody line. This is always more difficult when a piece or selection thereof is built on

arpeggios. Segovia was kind enough to edit the piece with upward stems on the melody notes and one should 'bring these notes up' when playing the piece. Apoyando works nice, but I am getting ahead of myself.

Let's look at the first two measures:

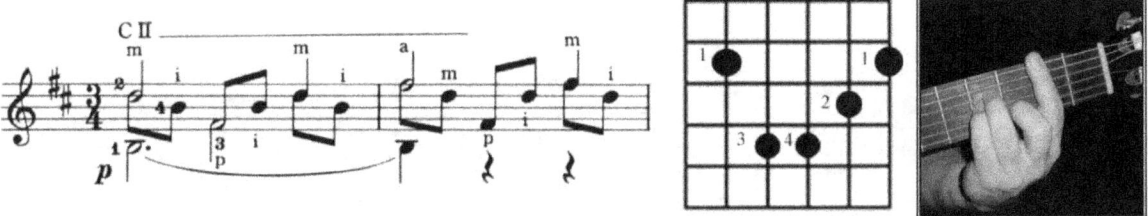

It is necessary for the left hand only to find the B minor chord shown at right to produce every note (and hold them for the correct duration) in the first two measures of the Etude. Six beats down, zero left hand motion. Then we move.

Measure Three:

 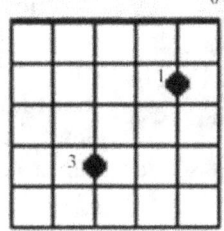

When transitioning to measure three (the first change of hand-shape) the third finger remains in position on the F# on the fourth (D) string. The third finger will be used as a 'planting' finger – a finger upon which all changes are rooted – in much of the piece.

In the accompanying photograph, you will note my second finger is fretting the A# on the third (G) string. I do this merely because this is a chord shape that will be used later in the piece and I find it easier in my own playing to keep my hand/chord shapes consistent when possible. The student need not follow my example; however, the planting of the third finger is critical. So finger 3 stays down when transitioning to measure four.

Measure Four:

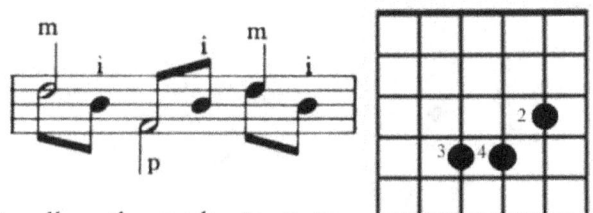 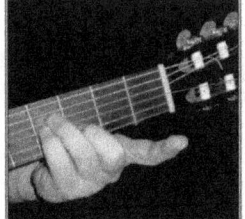

Measure four returns to the tonic chord, but not the Grand Barré form found in measures one and two. In the photograph, I have extended my first finger to allow the reader to more clearly see the other fingers. I do not recommend holding the left hand like this in performance. Please note: the third finger has not moved since the initial placement in measure one.

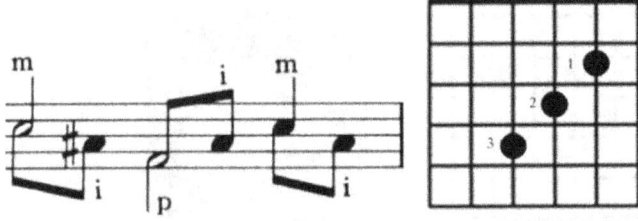

Measure Five returns to the dominant of the key of B minor (an F# major triad.) and is fingered thusly:
Please see photograph for measure three for an example of how this looks in execution. As one can readily see, not much has really

happened harmonically–just the very definitive assertion of the B minor tonality through the use of the I/V relationship.

Measures Six, Seven and Eight commence by presenting the resolution of the dominant chord in arpeggiated in measure five with (naturally) a tonic b minor, only to quickly return via a passing chord and a passing tone to the dominant to end the first phrase of the A section:

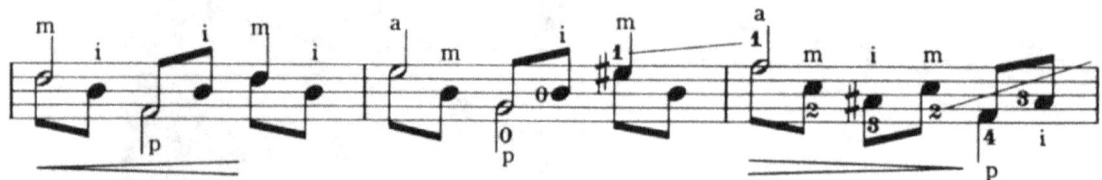

Measure Eight is shown in the accompanying diagram and photograph:

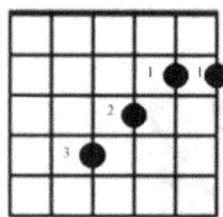 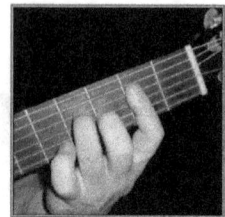

The half barré is a personality quirk of mine. This chord could be played much the same as a three-fingered open-position F major chord that all students learn early on. As I have written previously, I try to use identical hand shapes for similar chords to keep the changes easy to remember. The end of this phrase, as stated previously, lands upon the dominant tonality of F# major. Sor begins the second phrase of the A section with a very familiar melodic/harmonic motif in measure nine:

Measure nine relies upon the same B minor chord hand shape as seen in measures one and two. Measure ten incorporates a new wrinkle on the old formula by including the F# on the second fret of the first string which is fretted with the first finger but omitting the B note played on the fifth string (and held as a tied note in measure two.) One can use the same barré chord as used in measure ten as was used in measure nine—in fact one should. Measure eleven is identical to measure three and needs no further illumination.

Measure Twelve: Departs from what we have become familiar with in the first phrase. Rather than following the tonic/dominant chord change with a tonic chord, Sor moves us to a G major chord (the VI chord of B minor) which leads to a C# diminished chord in measure thirteen (one that is often read
as an A7 chord—an honest, though erroneous, interpretation based on the chord shape produced by the edition fingering. In measure twenty-seven, the left hand will perform the same fretted pitches and the result will be an A7.) The C# diminished resolves to a tonic chord in measure fourteen identical in construct and fingering to measure four.

 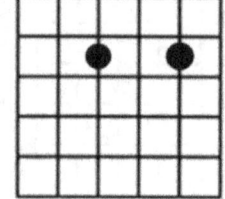 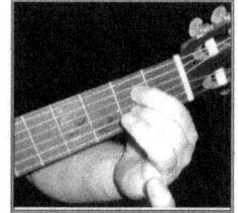

used to very briefly (just one measure) modulate to a new tonality—E minor. I particularly enjoy this portion of the piece. Note the placement of the third finger in the B7 chord.

 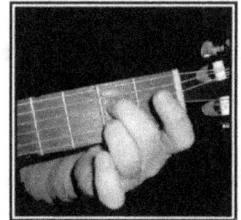

Sor then moves the piece through an A7 tonality used as a dominant of D major to a beautiful C major chord in the first inversion (measure twenty-nine) with the open low E string supplying the lowest pitch.

Please note fingering for measure twenty eight. The D major chord is arpeggiated with an open string and a fretted note on the same string.

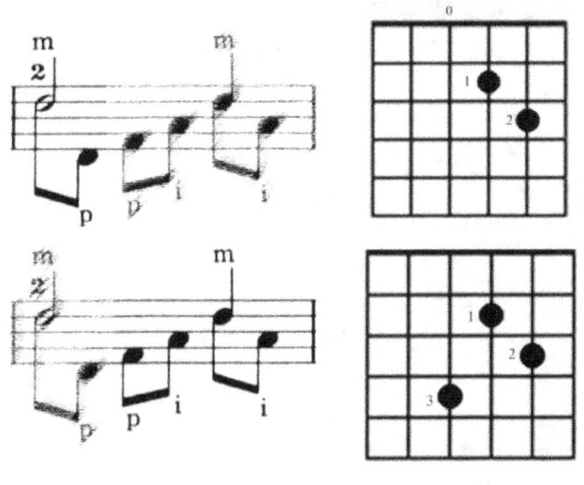

Note: on the first beat the first finger is fretting the D on the second fret, B string. The D one octave below is played as the open string. On beat two, the third finger comes into play, fretting the F# on the fourth fret on the D string.

In measure twenty-nine Sor gives us a lovely change-up to the expected harmonic progression and writes a C major tonality in the first inversion. This is prolonged in measure thirty as a continued arpeggio figure completed with the fourth finger of the left hand.

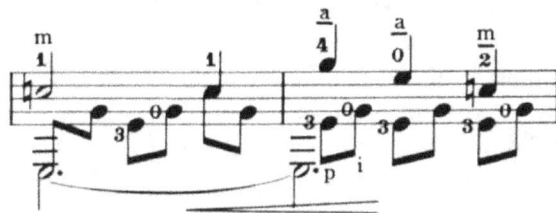 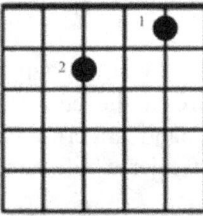 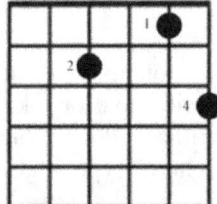

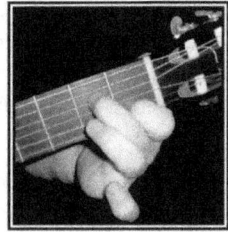

Please note that the notes fretted in measure twenty-nine remain down throughout the two measures. The open E is also tied into measure thirty, so nothing changes with the left hand until the fourth finger drops in at measure thirty to execute the G note on the third fret.

Measure fourteen moves to the identical dominant in measure fifteen as is present in measure five. Measure sixteen is a new form of that same chord found in measure one (and elsewhere) and an identical fingering produces all the pitches required to correctly complete the measure. At this point we can stand back and say that the A section of the piece is comprised of two phrases, each eight measures in length. Phrase one leads us from tonic to dominant (having once established the tonal center) and phrase two leads us back to the tonic.

The B Section:

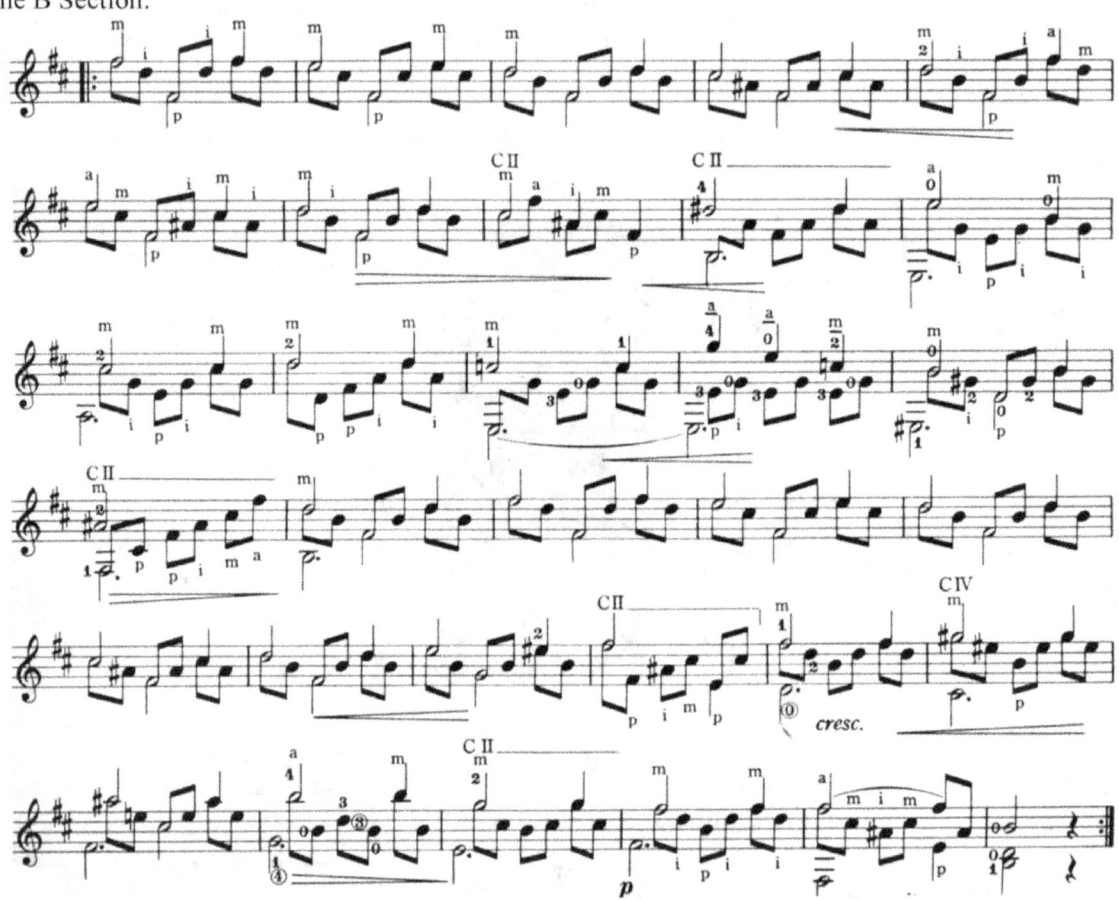

This section is contains the measures that cause the student the most difficulty: measures forty-two through forty-six, give or take a measure at the end of the run. As in many pieces (read: most) fingering is critical. Poor choices in left hand fingering can paint the student into a corner "you can't get there from here"-type fingerings will render whole phrases unplayable mine fields.

The chord forms/hand shapes remain consistent with the two phrases in the A section until measure twenty-one where an extra F# is added (using the first finger on the first string, second fret) to the basic B minor form. See the photograph in the paragraph regarding measure four. This is the basic hand shape. Simply place the first finger seen wagging in the aforementioned photo and place it on the F#.

Measure twenty four is the dominant chord and leads us to a surprise in measure twenty five. This chord is

Measure thirty one contains an interesting harmony. The E# is a passing tone to the dominant that arrives in the next measure, measure thirty two (E#? Yes, a theoretical note even though it is an F in execution; think of it as you would an A# and a G♭, the same pitch, but capable of assuming an alias!) The chord itself? Think of it as a transitory assembly of passing tones—the E# passes to the F#, the G# passes to the A#, the D to the C etc. Treat it accordingly—I particularly like to accent the interesting quality of the chord by approaching with a bit of rubato and dynamics changes.

Measures thirty three through thirty nine are identical to the first phrase of the A section of the piece. The performer should determine how to phrase this section so that it doesn't sound merely like a repeat of the original theme, but a reiteration of that theme leading to the finale of the piece. Consider dynamics, rubato, tone shading and any other color on your musical palette. Measure forty is nothing new, but it does contain the seventh of the chord making the chord not just a dominant, but a dominant seventh (dom^7.) Sor did not use this harmony to complete the first phrase of the A section. I believe he did this so that when he reiterated the phrase in the B section it would be even less stable than the plain dominant and would really pull the ear to seek resolution.

Now begins the phrase that stymies students – a chord progression that leads to the final cadence.

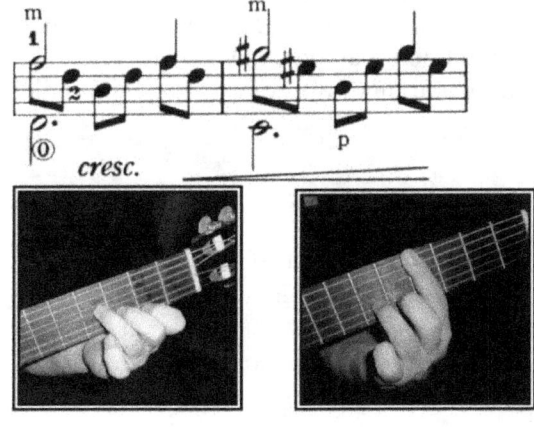

The Barré IV C#7 chord is no big deal, but fingering is critical in preparation for the next measure. The next measures, forty three, forty four and forty five contain the hand shapes with which the student invariably has the most trouble. Correct fingering (as I always say) is crucial. With correct preparation through correct fingering, these measures are not as daunting as they first appear.

Please note the similarity in fingering between measures forty-three and forty-four. The right hand fingering pattern remains exactly the same which sometimes perplexes students as there is the funny feeling of reading a chord with an open string in its midst in forty four. In forty three the second eighth note is higher in pitch than the third, In forty four, this relationship changes—the source of the perplexity.

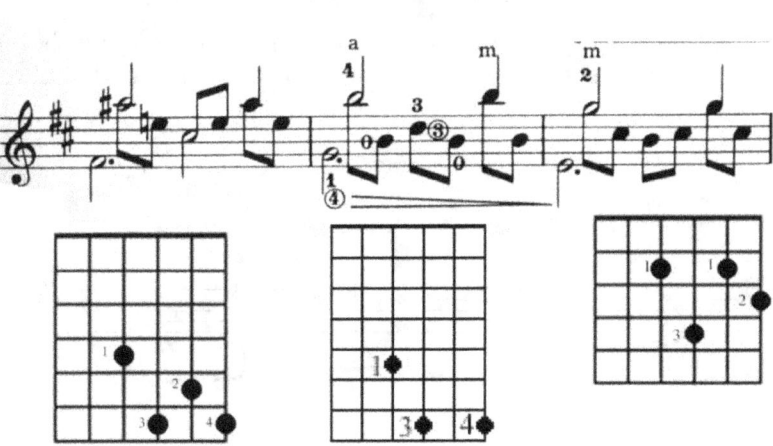

Measures forty-six, forty-seven and forty-eight contain no new material and are reiterations of familiar hand shapes from earlier in the piece.

Overall, what have we at this point? Etude Five is a seemingly straightforward exercise with good examples of Sor's lovely compositional hallmarks. What the student must do is to complete a twofold mission. The first mission is to master the technical aspects of the piece. Now I say 'first' and 'second' but the intent is to complete these missions simultaneously – or as close thereto as possible. The second mission is to create a pleasant musical experience for the listener (and performer!) which is what I will often call *bringing something to the party*. This piece is fairly repetitive so it is important that the student formulate a plan to make each phrase a unique musical statement and that there are musical climaxes where required and/or applicable. The B section contains a phrase that begins on a B7 setting up a brief sojourn into E minor. That phrase is a good place to build the drama and the student should consider both volume/and dynamics as well as rubato and tone to focus the listener's ear onto what the student wishes to accentuate. After this phrase resolves, the piece returns to a phrase that mimics the A section. That final progression that leads to the final V7 – I resolution should be the height of the emotional experience and should be planned for. It is not simply "the end".

Edition Fingering: Is it right for your hand? Is it right for the music?

In any guitar music, be it a piece specifically written for the guitar or a transcription from another instrument's repertoire, there will be suggested/recommended/required fingering added by the composer, transcriber or an editor. Some players treat these as sacrosanct; others disregard them and follow their own ideas of physical comfort, their belief re the intent of the composer/transcriber. Most guitarists beat a path somewhere in the middle ground whereupon they follow the fingerings in their chosen edition making changes only if absolutely necessary – if they believe there is a mistake in the edition or if a facsimile edition of the composer's work indicates a different fingering.

Please see the short article on voicing and timbre elsewhere in this volume.

Often none of these considerations make the 'change' in the fingering. Most often it is a fault of memorization. When one memorizes a piece, there is always the possibility that although something sounds right, it is being memorized incorrectly. This is why it is critical to memorize any pieces with the music on the stand in front of the guitarist. It is also critical to go back to the printed page every so often to ascertain whether the performer has unintentionally changed things—including actual notes – with the fingerings.

Of course, there are times when the guitarist immediately discounts an indicated fingering on the initial read-through and proceeds to use this fingering to the detriment of the performance. How? I will use the following example from Albéniz' beautiful piece *Sevilla*.

I have played this piece for a number of years. I use a combination of the Francisco Tárrega and Manuel Barrueco transcriptions. The first measure of the particular phrase above is fingered per the Barrueco transcription. The second measure is how I played it. Note the only difference—a half barré at the eighth fret rather than the full barré. I would always become apprehensive as this phrase approached during any performance. Sometimes I'd

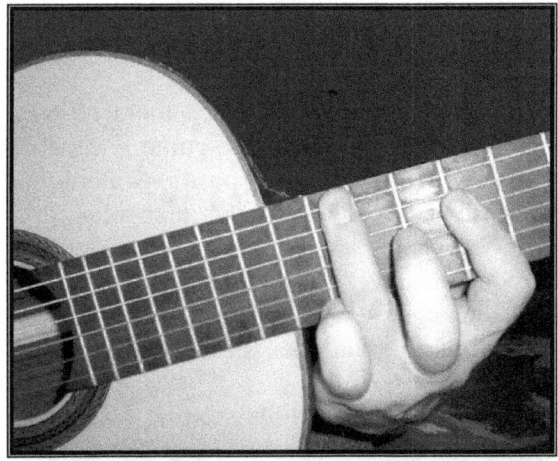

execute it cleanly, sometimes not. After many times of checking the actual notes played, I finally went back to look at the music carefully paying particular attention to the fingering. The photograph to the left shows my version of this chord utilizing a half barré at the eighth fret. To jump into this formation, my wrist had to change position rotating towards the heel of the neck. This is where my difficulty came in. Unless I rotated my wrist correctly, the half barréd notes on the fourth, third and second strings would often be muffled. Hence my apprehension when this measure approached. Well, after years of this aggravation, I looked carefully at the fingering and tried the full barré. See photograph to the right, below. Instantly, I could jump up into this chord and nail it cleanly, perfectly, forcefully – every time!

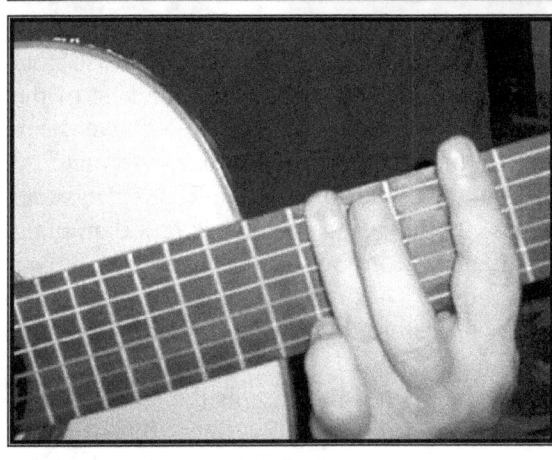

Of course, I had to know why this remarkable miracle was occurring. When I first learned *Sevilla*, I was more concerned with making sure I had the correct harmony/chords in this passage. It is a critical passage, very dramatic, as a turnaround into the original motif. Being a fond proponent of using as little energy as possible to execute a piece, I probably figured the half barré was more than adequate to take care of three notes on adjacent strings on the same fret. I did not factor in the wrist motion and committed my faulty fingering to memory. On consequent read-throughs, I made certain the notes were correct, but never looked twice at the fingering.

So in this instance a fingering that seems to force one to expend more energy is actually more comfortable to execute. In this instance it is more productive to invest a bit more energy to get an easily replicated phrase than to save a bit and waste a clean performance!

Revoicing Chords for Positional Use

The simple D Major chord as pictured to the far right can be permutated through its first inversion, its root position and finally, far left, to its second inversion. While any one of these chord shapes can be used anywhere along the fingerboard, it is necessary for the guitarist to be familiar with all inversions in any given location. For discussion, we will examine the chord as it appears when the first finger is in the half barré at the fifth fret; an F major configuration.

Note that for root position, the fourth finger frets the f note on the fifth string, eighth fret. The gray circle indicates the fourth finger fretting the c at the eighth fret of the sixth string which would yield the second inversion of the chord. The hand shape demonstrated earlier in the book and labeled 'D major First Inversion' could also be used at the fifth fret (the first, second and third fingers as shown in the diagram to the left with or without the half barré) to generate the first inversion of the chord.

Other chord shapes familiar to the experienced guitarists can be generated from 'bridging' the pattern demonstrated to the left to the forms diagramed earlier.

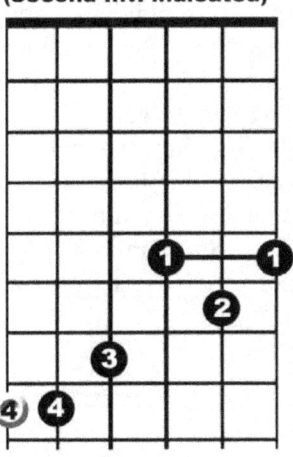

F Major (Expanded) Root Position (Second Inv. indicated)

F Major (Root Position)

See diagram to the right. Fingers one, three and four fret the following notes: one: f, three: c, and four: a. This results in a root position triad. (Please note: the gray circles represent the fretted notes in the form from which this variant has been derived.

Student guitarists are often frustrated when they first encounter compositions that force them to play pitches above the fifth fret. This frustration is caused by one single factor. Unlike the piano, the guitar is capable of producing notes of identical pitch, though not identical timber, at as many as four different positions along the fretboard. While this may seem daunting or unnecessarily complex, when viewed as an asset rather than a liability, it opens up a vista of possibilities.

The guitar relies upon the stopping or fretting of strings to produce changes in pitch other than the six possible pitches afforded by the open strings. Because of the varying diameters of the strings as well as their differing masses, and the fact that fretted pitches have a different tone and decay than open strings can produce, identical pitches played on different strings produce a different tone or timbre.

Guitar strings are designed to produce an acceptable volume with good tone while exerting a level of pressure on the instrument that will not cause its (the guitar's) components to fail prematurely. Bass strings must vibrate at a lower frequency range than the treble strings. For a plain unwound or solid string to vibrate at a low frequency while remaining in tension parameters, it would have to be exceedingly large in diameter. Please note that most classical guitarists complain about the tone of their guitars' g strings. The g string is the thickest of the unwound or plain strings and is often referred to as having a 'tubby' sound. Manufacturers have been experimenting with varying degrees of success with materials other than nylon added to the nylon base material (or even gut) to produce a better sounding g string. These materials include composite/carbon fibre strings and a titanium-nylon polymer. These strings do indeed produce a brighter less 'tubby' string with more feel than plain nylon but are ridiculed by some guitarists as not sounding traditional! The sixth through fourth strings are silver plated nickel or copper wire wound around a nylon (or composite) floss core. These strings produce the lowest pitches the instrument is capable of and function under the lowest tension. Therefore their mass and firmness must be greater in order to produce these lower frequencies at an acceptable volume.

As notes are fretted along a string – progressing up the fretboard – the pitches increase as the length of the string is shortened. Tension in increased as the length is shortened. This increase in tension causes the string to produce a different timber as well as pitch. These variances in timbre can be used by the guitarist to 'color' the tone of the pitches to better evoke a mood or emotion. The highest pitched string, the first or 'e' string is probably the most strident in tone. Lutenists, in the heyday of that instrument, referred to the highest-pitched first string as the chanterelle as the melody was often required to be performed upon this string. It was brighter and louder (and a single string rather than a double course as the rest of the instrument was normally strung) but does the guitarist always want the brightest string to carry the melody?

Noted guitarist, teacher, transcriber and arranger Andrés Segovia (February 21, 1893 – June 2, 1987) often referred to the guitar as an orchestra as viewed through the wrong end of a telescope. What he further explained is that each string is like an instrument of the orchestra. "The guitar is a small orchestra. It is polyphonic. Every string is a different color, a different voice." He compared the first string to a flute, the second string to a trumpet, third string to a violin the fourth string to a cello and the lower strings to the bass. He could indeed draw these tones from his instrument!

However, there is a certain complexity to be able to produce the same notated pitch in various locations on the fretboard. This phenomenon is naturally inherent to the instrument. It panics the newer guitarist into forcing the fretted notes required by the notated music down into open position—where possible. This generates some amazingly difficult fingering with the added possibility of a detrimental effect on the timbre of the instrument. Therefore what should be a great freedom becomes a morass of frustration and liabilities.

Within this book we have and will continue to will explore the why's and wherefore's of fingering. There is more than one way to finger any passage. Some will result in either difficult fingering (strange and uncomfortable left hand shapes) or difficult transitional fingering (the difficulty of getting from one hand shape to the next either through large fret jumps or lack of any common fingers or shapes within sequential hand positions.) Some will result in unwanted or even unpleasant timbral coloration. But there are variables. Sometimes the most efficacious fingering will sound lackluster. The most beautiful tones may result in hideously difficult fingerings and transitions. Deriving the best possible fingerings can be considered something of an art.

Stopping Those Squeaks!

John Williams was once asked "How do you feel you could improve your guitar playing?" His answer was a simple: "I'd like to not squeak when I play." To my recollection, I cannot remember Mr. Williams having any kind of squeak issue, but to him it was still a goal to be achieved.

Squeaks occur when the tips of the fingers slide along the wound strings. It is like bowing a violin string. The skin of the fingertip rubs against the metal windings and mechanically excites the string in the high harmonics yielding a high-pitched squeak until motion has stopped. Using wound strings, I believe it will be impossible to totally eliminate squeaks. There are some 'studio' or 'recording' string sets on the market that unitizes a polished or ground wound bass strings that helps to minimize finger noise, but these are rather expensive string sets and some players have reported a 'duller' sound from the basses.

Here is a rather famous passage that almost always results in a high degree of finger noise. This is the opening two measures of Francisco Tárrega's *Lágrima*. Although the hand shape changes over the first three beats of measure one and the first beat of measure four, the same two fingers execute the fretted pitches. Most new students are taught to maintain contact with the fingerboard either through keeping common pitches fretted within a set of measures or a phrase, or to slide the fingers when similar hand shapes allow. These practices help the student 'find' the notes – or at least they reduce the likelihood of not finding a note (or notes) that will be required within a short span of time.

The end result of this is that one often hears the first two eighth notes (beat one) followed by a grand squeal, then the second two eighth notes (squeal), the final two eighth notes of the third beat of measure one and then a large squeak as the student drops into measure two. If the player totally releases pressure between each beat to move, the result is a rather staccato presentation of the phrase. This is not desirable either. What is one to do?

Let us dissect the motion involved to produce the pitches. Fingers one and four are fretting notes on the fourth and first string respectively. Finger one is on a wound string, finger four frets a plain nylon string. One can readily see the solution form just this information! It is the first finger that is generating the unwanted sound. The solution is to release pressure on the first finger when shifting position, but to use the fourth finger as the guide finger and slide on that without releasing all pressure. A reassuring level of contact is maintained with the fingerboard while the unwanted squeak is now just about gone. I write 'just about' as the simple act of releasing pressure on a wound string can result in a slight amount of noise.

It is important that one remembers that tone production is a symbiotic as well as synergistic relationship between the left and right hands. Both come into play in a way that is intricate as well as exceedingly helpful and gratifying to the performer.

Performance Notes for Etude Number One in E minor
By Heitor Villa Lobos

Considered by many to be concert etudes, Heitor Villa Lobos' etudes were often included in recital programs during the 1960's and 1970's. For a time it would seem they fell out of favor with many guitarists and were relegated to the more mundane tasks of the pedagogical duties they so aptly demonstrate. While these etudes do indeed discharge these duties with great attention to detail as well as a large dose of panache, they do not occupy the same lofty position in the *pantheon of fine repertoire* that they once did. Whether one approaches the Villa Lobos Etudes from the pedagogical or the artistic, there are certain suggestions, recommendations and hints that can be imparted to the guitarist that will ease the journey from 'new piece' to 'performance jewel.' The first musical example (measures one through four) is taken from the Max Eschig (Paris) edition of 1953.

Please note the right hand fingering as demonstrated beneath measure one. This pattern unless otherwise indicated, will be implemented to arpeggiate the left hand positions/hand shapes in each subsequent measure.

Measure one is a simple e minor chord executed by placing the first finger of the left hand on the B on the fifth (A) string at the second fret and the second finger on the E on the fourth string at the second fret. All other indicated pitches are produced from the plucking of open (unstopped) strings.

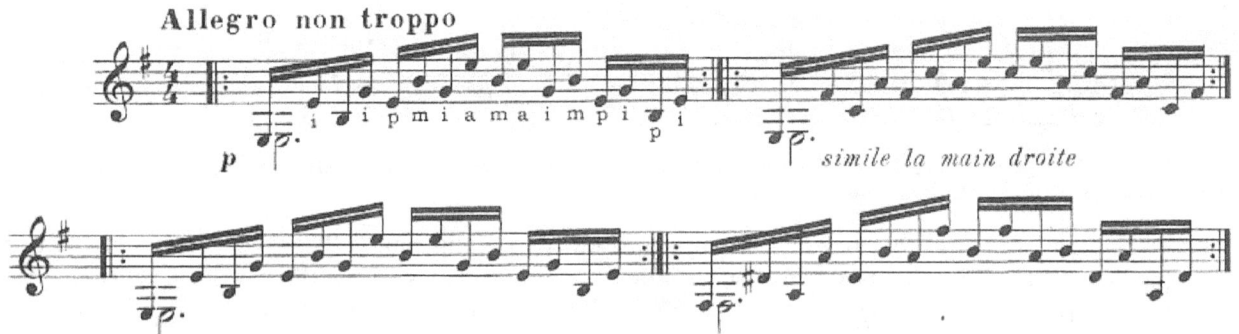

This simple hand shape must be prepared this way in order to successfully make and the transition to the hand shape in measure two. Left hand fingers three and four must move immediately to the F sharp on the D string at the fourth fret (finger three) and the C on the A string at the third fret (finger four) and have the opportunity to do so as they are not previously engaged and can 'hover' near their targets during measure one. Once fingers three and four have been used to fret the indicated notes, there is a very brief amount of time for the first and second fingers to move to the A at the second fret of the G string (finger two) and the C at the first fret of the B string (finger one.) This is a fairly difficult hand shape for many students to transition. [Below: My fingering added to the Eschig edition.]

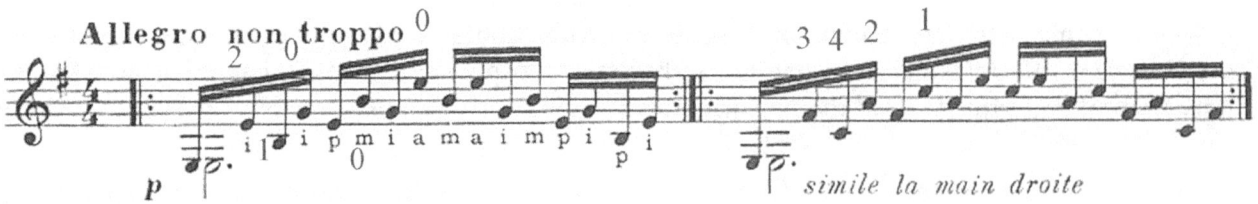

Although measure three contains identical pitches fretted in identical manner as measure one, due to the transition to measure four, measure three will be fingered differently. [See first example above and compare the two measures.]

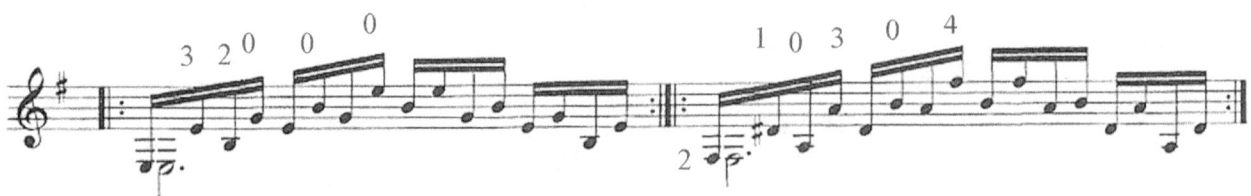

If the first finger of the left hand on the B on the fifth (A) string at the second fret, then finger two would have had to shift two strings over to execute the F sharp on the second fret on the E string while finger one would have had to travel around finger two to execute the D sharp on the first fret of the fourth string. This would feel clumsy—and sound clumsy as well!

Measures five and six comprise a very difficult transition for many students and guitarists with small hands/limited finger stretch. The guitarist is faced with a first inversion E minor chord similar in construct to the root position chord in measures one and three. The basic fingering is the same as that employed in measure three with the addition of the third of the chord (G) fretted on the third fret of the sixth string with the fourth finger. The transition from measure five to measure six is accomplished by sliding the fourth finger up one fret (one half-step) to the G sharp on the fourth fret and a corresponding doubling of the G sharp one octave higher by fretting the third string at the first fret with the first finger. [See example below.]

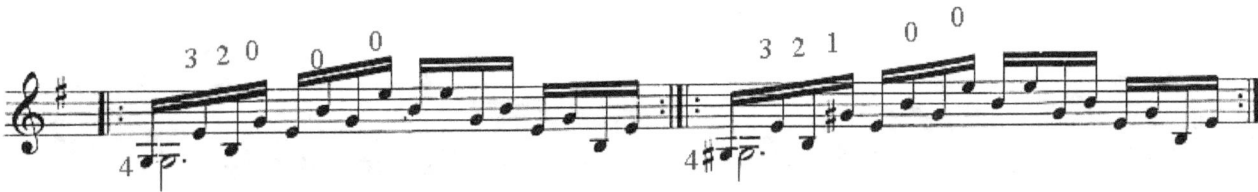

From measure six to measure seven t the guitarist encounters a change in position from the so-called open position to a position generated by barring the fifth fret. The chord arpeggiate din measure six is a simple A minor chord in Grand Barré form. This should be relatively easy to accomplish by all guitarists aside from the true beginners. I have noted that some students have had difficulty with the transition from measure seven to measure eight though. If the basic mechanics of the transition are observed, the transition becomes quite simple. The guitarist should realize first that the first and third finger need not move at all when making the transition from measure seven to measure eight. They remain stationary. The first finger that must move is not so much a movement per se but an addition. The second finger (which was not employed in measure seven) is used to fret the B flat on the sixth (E) string, at the sixth fret. The fourth finger simply moves from the fourth string, seventh fret to the third string, seventh fret. As stated, once the guitarist comprehends the mechanics of this transition, it is simple to accomplish.

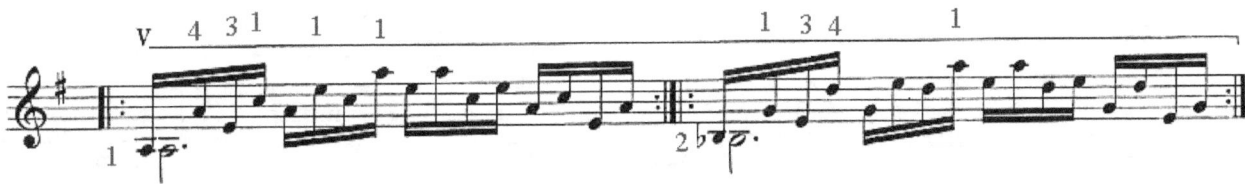

The following three measures (nine through eleven) prepare the ear for what might be considered the B section of the piece. They offer no challenges that require discussion here. The next excerpt begins the B section at measure twelve. The open sixth string E allows for (rapid) finger placement in what at first seems to be an odd hand shape but is actually a combination of two very familiar hand shapes. [This excerpt includes measure twelve through fourteen then proceeds directly to measures nineteen through twenty-one.] The hand shape produced to execute measure twelve is repeated in each measure as it moves one half-step at a time to an open position chord in measure twenty-two. Observe that many performers accentuate the note that falls on the second sixteenth note of beat two and the first and fourth sixteenth notes of beat three. These notes are all plucked by the right-hand middle finger (*m*). This becomes problematic for many players when they arrive at the seventeenth where the fretted E on the b string, which is accented, is accompanied by and juxtaposed with the open E string (plucked with *a* finger.) The accent is often obscured. The player should be mindful of this technical phenomenon and ensure that the

accents remain consistent. It is also customary two perform each measure *forte* the first and at *piano* on the repeat. I do not pass any judgment on this performance practice; I observe what has become a common process.

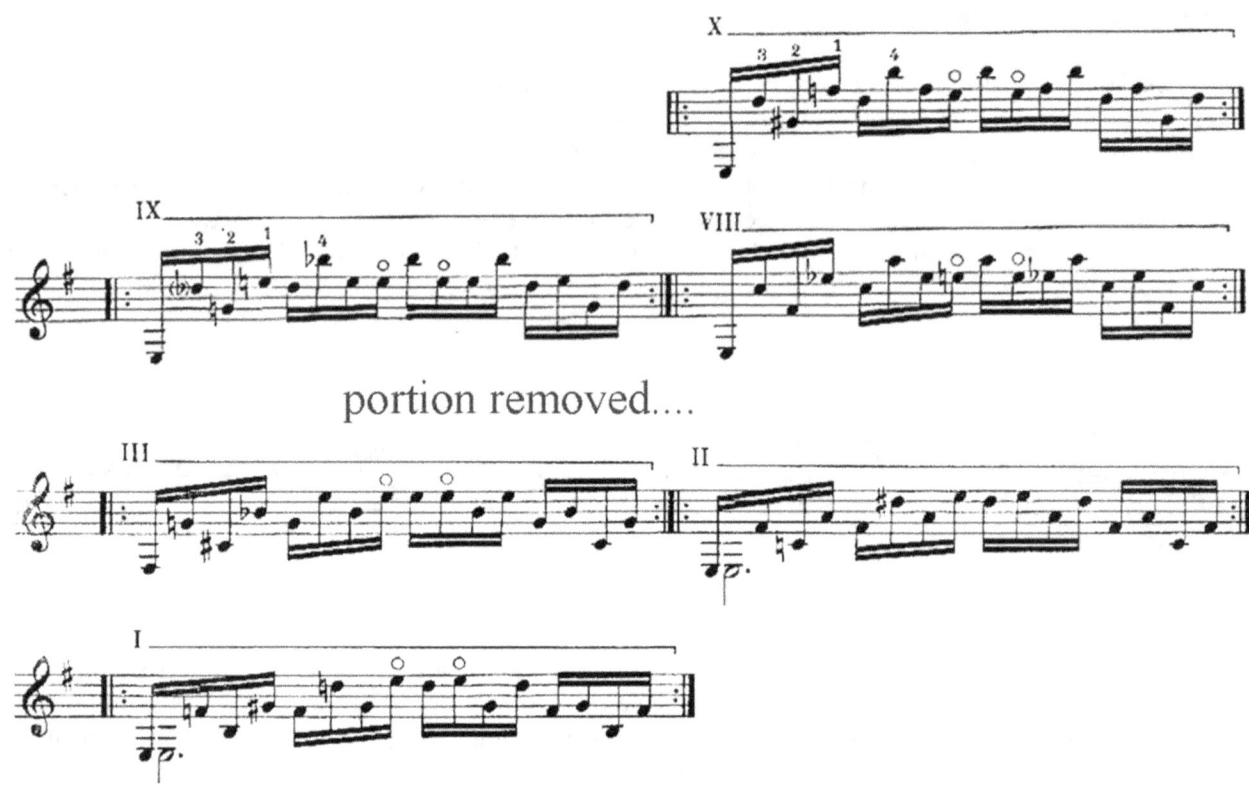

Another issue is transitioning between each measure without generating finger 'squeaks' on the wound strings. It is all too tempting to slide the hand down the fingerboard one half-step each measure without releasing pressure. Those open sixth string E's on the downbeat of each measure are when the strings should be released— one should not attempt to release pressure *before* this E is plucked. See below:

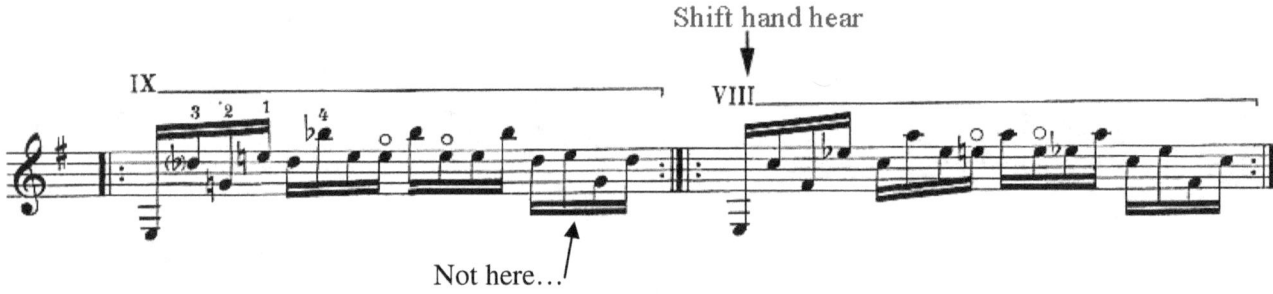

By releasing pressure and carefully lifting all fingers when the open sixth string has been sounded, the possibility of finger 'squeak' is greatly reduced. The guitarist should practice this passage slowly, making certain that the previously mentioned accented notes do indeed carry the correct articulation (the notes that fall on the second sixteenth note of beat two and the first and fourth sixteenth notes of beat three) and that the desired dynamic change between repeats, whatever the guitarist may feel this may be, have been executed. Gradually increase speed *after* the passage can be performed flawlessly at any given slower speed.

The next problematic passage occurs at the completion of the descending chromatic passage, occurring in measures thirty and thirty-one. The original edition is fingered as it appears below.

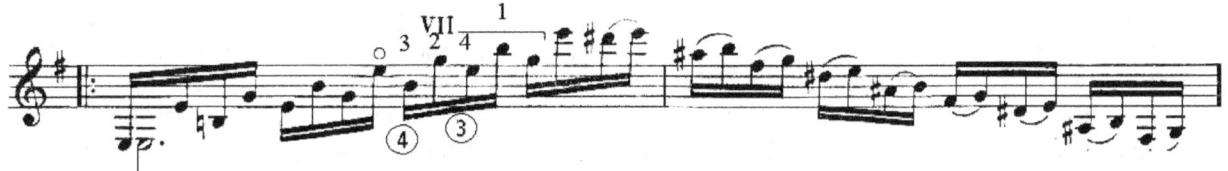

While this fingering works and is not to be discounted out of hand, the area that affords considerable difficulty fingering-wise is (strangely) left unfingered. Measure thirty-one can be fingered in a number of different ways, but I have found that some work less well than others. A fingering I have found works well is shown below.

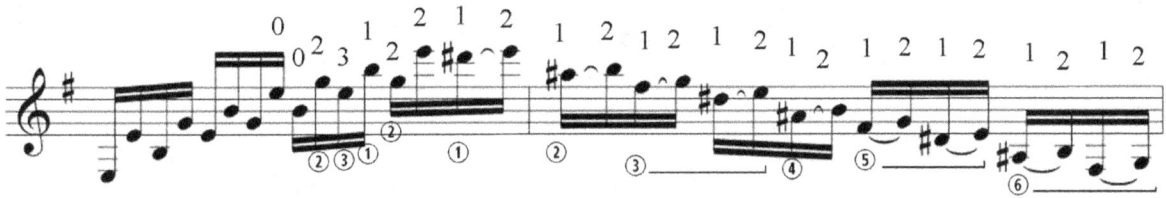

There is a sense of cadence towards the end of measure thirty when the first high e is plucked. While not to be treated with total rhythmic license, a very slight breath pause can be considered here before beginning the descending half-step legatos. The student must keep two things in mind during the execution of the final beat of measure thirty and the entirety of measure thirty-one: *the even sixteenth note rhythm pattern **must** be maintained.* There should be no noticeable decrease in tempo in relation to the rest of the piece. There cannot be any 'syncopation' inherent to the poor execution of the hammer-on legatos between the half-steps.

There is one quirk in 1970's performance practice that I must address. In the original edition there appear these measures:

Note that the two measures are repeated *across* the chord change rather than individually as every other change in the piece is executed. While this is as it appears in the original manuscript, many performers changed the repeat to follow the rest of the piece:

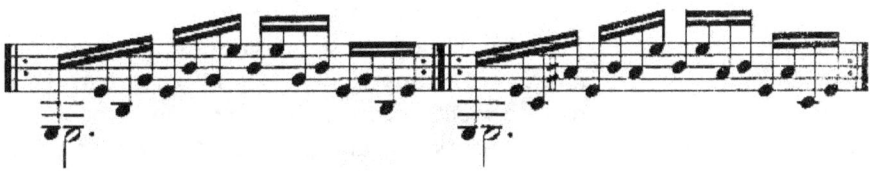

I have great faith in Sr. Villa-Lobos' compositional skills as well as Max Eschig Editions' staff to correctly engrave from manuscript for the greater part. I include these paragraphs to indicate what many noted performers played (and, indeed, a 'correction' my teacher Albert Valdés-Blain, made to my copy.) The reader may incorporate or discard as he or she may wish.

The final three measures of this etude offer the guitarist a challenge and a great opportunity. The challenge? Deciphering and executing the harmonics as indicated. The opportunity? A chance to perform a truly lovely finale to this extraordinary piece of music. The first stumbling block to overcome is purely one of notation. While I find the Max Eschig edition of the Etudes and Preludes to be definitive, they were engraved during a different age. Note the way strings are indicated – encircled capital letters. This is can be justified to be an ambiguous method to indicate strings as it does not take into account that the guitar may be tuned to an alternate tuning. Of course, for this piece of music, the guitar is not, but in such an instance, it would be misleading. [For example, if the guitar were to be tuned in drop D tuning, how would the performer know *quickly* which d string the editor intended?]

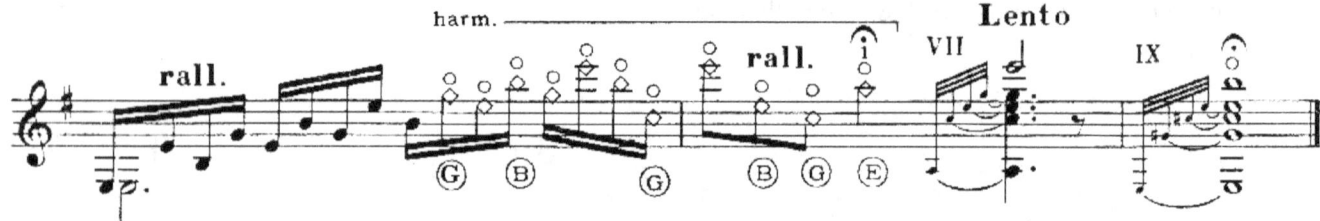

A more modern way of indicating the correct harmonic and where it should be played would be to engrave the passage as shown below – with encircled Arabic numerals and fret numbering as is found in most modern editions containing similar passages. The Max Eschig engraving is very precise though, once one is acclimated with the method. The diamond shaped note-heads indicate what the fretted pitches would have been at that fret – NOT the pitches produced (or even an octave variant thereof.) This takes a bit of mental imaging the first few times through. I have included strings and fret indications over the old Eschig engraving. This could have been engraved with actual produced pitches, but I believe the reader will follow the numbers I have added correctly:

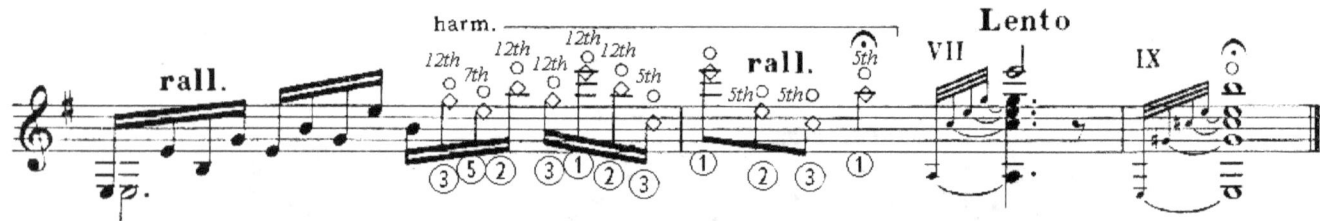

Many also substitute a harmonic 'e' at the twelfth fret in the penultimate chord to mirror the harmonic atop the final chord. There is more than one possible fingering for those two final chords of the cadence. Timbre will decide for the performer which is the better choice. Choice of fingering will also decide whether to observe the single harmonic or to either eliminate it or have both a harmonic 'e' and a harmonic 'b' capping their respective chords

A note on practice for this piece: The key to musical and technically proficient performance of this etude depends upon stringent practice at very slow tempo. It is all too easy to 'practice' this piece too quickly as speed disguises mistakes (accent, rhythm, and pitch as well as poor tone) making them *almost* inaudible. Repetition of these 'mistakes' will reinforce the error, make the erroneous reading sound correct in the ears of the performer and—possibly the worst aspect—be very hard to correct. Once memorized, an error is very difficult to forget! Practice the etude slowly enough that the rhythm remains constant, all accents can be executed to the performer's taste and according to plan. Dynamics should be incorporated as soon as the piece can be successfully completed at the slowest tempo. Speed comes through accurate repetition at slow speeds. Tempo should only increase as the piece becomes comfortable for the performer at the level of the previous tempo increase. This is just common sense practice technique and should be the method used with any new repertoire and to dwell more on the subject is outside the purview of this article.

Harry George Pellegrin was born February 4, 1957 in Bronxville, New York, United States.

Musician, writer, photographer, and graphic artist. The only child of Harry Pellegrin (1902-1981) and Veronica M. Pellegrin (1918-2004), Harry G. Pellegrin attended Mount Saint Michael Academy in the Bronx, graduating in 1974. Pellegrin studied piano as a small child but became interested in the guitar in 1970 and by 1973 was performing. Pellegrin attended Bronx Community College from 1974 to 1976. He majored in classical guitar at The Mannes College of Music in Manhattan, studying with Albert Valdés-Blain and Eliot Fisk.

A severe traffic accident in 1989 resulting in fractured thoracic and lumbar vertebrae with some permanent damage to the spine and the associated neurological deficits curtailed his musical career for almost seven years and channeled his energies towards his other interests, writing and photography. Pellegrin wrote for *Soundboard, The Journal of the Guitar Foundation of America* and *Ironhorse Magazine* before publishing his first novel *Low End*, in 2003. The first of a series, *Low End* (ISBN 1589820746) was followed by *Deep End* (ISBN 1435721985) in 2006. *Classic Guitar Method, A Comprehensive Method designed to transform the student from novice to recitalist* (ISBN 978-0-557-26825-2) combined Pellegrin's writing skills with his musical expertise. Pellegrin performed his come-back recital at the Troy Savings Bank Music Hall in Troy, New York on February 13, 2007, his first classical performance since the 1989 accident.

In May 2008 PAB Entertainment Group released *The Guitar* (700261240428) a CD of solo classical guitar music performed by Mr. Pellegrin which includes a number of compositions by the performer. In 2010 PAB released his second album of solo classical guitar *Old and New* (885767622234) which includes favorites of his from a number of stylistic periods. Pellegrin also composed and recorded a series of four brief waltzes for this CD, two of which are dedicated to his parents and celebrate their lives and chronicle his sense of loss at their deaths.

Now residing in Northern New York State with his wife and daughter, Pellegrin performs, teaches and writes. Since January 2008 he has been a member of the adjunct faculty of Union College in Schenectady, New York. He was installed as a member of the Board of Directors of the CGSUNY for calendar year 2012 and is an artist member of the Monday Musical Club of Albany.

Now in one volume, much of what the novice classical guitarist will need to know to lead him or her to the recital stage. From proper instrument care and maintenance to the necessary technical skills, musical mind-set, and the standard repertoire—all are exposed and explored with enough detail and insight that the student will wish to keep this book handy years to come as a ready reference source. With the aid of a good teacher, the student will rapidly progress through Classic Guitar Method attaining technical proficiency and musical eloquence. A number of studies by Sor, Giuliani, Coste, Carulli and Carcassi are expanded and graded. Examples from the standard repertoire reinforce the techniques highlighted in the studies. Coil bound for use on a music stand.

ISBN: 978-1-4116-9442-2

Low End is an exciting new novel dealing with modern issues in the style of the classic 1940's mystery writers. Low End is murder mystery with a twist involving a least-likely detective, a disillusioned, New York City musician named Gary Morrissey. Gary finds himself involved in a murder investigation of his own making when shadows of government corruption and hints of premeditated genocide are cast over a friend's murder. The author's own experiences are reflected in his lead character, whose love for New York City and for its less-than-attractive suburbs and citizens emanates from every page and whose musical knowledge and expertise provide a unique background for the events that unfold. Some mild language and violence, no sex.

ISBN: 978-1-4357-2198-2

The 120 Right hand Studies of Mauro Giuliani, edited and annotated by Harry George Pellegrin. These landmark instructional studies/warm-up exercises have been overlooked by many pedagogues over the past two or three decades. It is time to rediscover their benefits. Included is a new edition of the works as well as a facsimile of the Artaria second edition. Included is a systematic examination of how the exercises are structured and how they should be practiced. This book is a must-have for the classical guitarist's library.

ISBN: 978-1-105-95307-1

Helen is the kind of girl you dream about. She's smart and confident, funny and affectionate, and she's killer good-looking. Gary has fallen for her, and fallen hard. Even so, he is still distracted by life's little happenstances. It's those minor things like, oh, crooked cops, shady club owners, illegal smuggling, and a few dead bodies. Still, Gary can't keep his eyes off Helen. Harry Pellegrin's mystery novel DEEP END is packed with eerily real sinister characters, music, interesting locales, bizarre spirituality and a plethora of corpses. Couple this with an exceedingly clever plot and we have this year's best beach-read. Serial killings and alternative spirituality discussed. Some violence, no profanity, no sex.

ISBN: 1589820746

Folio For Guitar is a collection of pieces for solo classical guitar that include four Vals Brevis (Brief Waltzes) as well as three tone poems. All pieces written by recitalist and composer Harry George Pellegrin. Difficulty level: intermediate to difficult.